LACE IN TRANSLATION

The Design Center at Philadelphia University

Curated by Hilary Jay, Carla Bednar, and Nancy Packer
with an essay by Matilda McQuaid

This book is published in conjunction with the exhibition *Lace in Translation*, organized by The Design Center at Philadelphia University and presented at the Goldie Paley House, Philadelphia University from September 24, 2009 to April 3, 2010.

Lace in Translation has been funded by The Pew Center for Arts & Heritage through the Philadelphia Exhibitions Initiative with additional support from the Marketing Innovation Program, The Coby Foundation, Ltd., and the Pennsylvania Council on the Arts.

ISBN-10: 0-615-29643-2
ISBN-13: 978-0-615-29643-2
Library of Congress: 2009942844

Published by The Design Center at Philadelphia University
4200 Henry Avenue
Philadelphia, PA 19144-5497
215.951.2860
www.philau.edu/designcenter

Distributed by the University of Washington Press
4333 Brooklyn Ave. NE
Seattle, WA 98195-9570
1.800.537.5487
www.washington.edu/uwpress

Lace in Translation was produced by The Design Center at Philadelphia University as a project of The Fabric of Philadelphia, a Design Center-led initiative to capture and communicate stories of the region's textile heritage. The Design Center believes in the profound impact of design on all aspects of life. Addressing a broad audience, the Center furthers the awareness and understanding of design, both past and present, through exhibitions, research, education, projects, and the stewardship and interpretation of its historical textile collection.

The Design Center Curatorial Team
Hilary Jay, Director
Carla Bednar, Assistant Director
Nancy Packer, Collections Curator

Catalogue Production
Research: Hilary Jay, Carla Bednar, and Nancy Packer
Design: GHI Design
Publication Editor: Joseph N. Newland, Q.E.D.

Exhibition Video Production
A Glennfilms Production
Director: Glenn Holsten
Editor: Ann Tegnell
Director of Photography: Christopher Landy
Audio: Paul Alfe
Re-recording Mixer: John Anthony
Production Assistants: Meg Sarachan and Leah Goldstein

Photography
Unless otherwise noted, illustrations and photographs are from the collection of The Design Center at Philadelphia University © 2010

Demakersvan: pages 36, 40, 41, 42 & 43, 46

DesignHouseStockholm/Studio CA: page 30

Glennfilms: page 39

Lynn Golden: page 69

Hagley Museum and Library: pages 9, 10, 18, 19, 20, 21, 24, 25, 26, 27

Joana Meroz: page 30 (www.joanameroz.com)

Digital image © The Museum of Modern Art/ Licensed by SCALA/Art Resource, NY: page 28

Nancy Packer: pages 35, 79. 89, 90 & 91, 92, 93

Kerry Polite: pages 11, 44 & 45, 46, 48 & 49, 64 & 65, 67, 68, 72, 73

Jack Ramsdale: pages 6, 7, 11, 13, 14, 15, 16, 19, 22, 23, 37, 40, 41, 58 & 59, 61, 63, 66, 70 & 71, 72, 74, 81, 83, 99, 100 & 101, 102 & 103, back cover

Christine Rice: inside front cover, pages 4, 14, 15, 80, 83, 84 & 85, 86, 87, 96 & 97

Alana Rosenwald: pages 62, 67, 89

Thessy Schoenholzer: page 31

Studio Tord Boontje: front cover, pages 4, 8, 12, 13, 53, 54, 56, 57, 60

Beth Van Why: page 88

Elizabeth Weissert: pages 94 & 95

Front cover and above: Detail of raffia lace sample by Studio Tord Boontje for *Lace in Translation*, 2008.

Inside front cover: Detail of oil tank by Cal Lane for *Lace in Translation*, 2009.

Flyleaf: Detail of machine-made lace sample by Quaker Lace Company, Philadelphia, early 20th century.

Contents

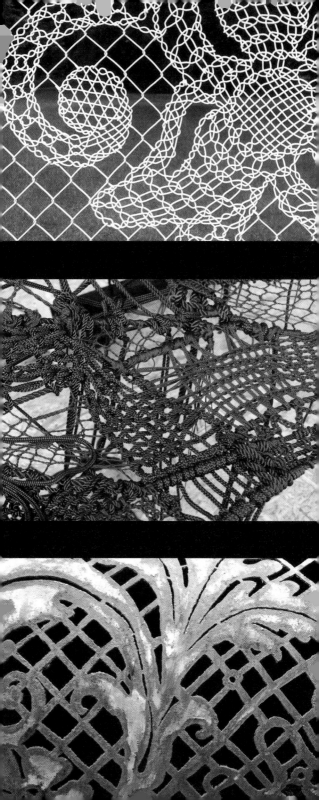

Lace in Translation

Lace in Translation examines the traditional art of lace-making, transformed though the lens of contemporary design, to inspire new works in non-traditional materials. Four years in the making, the exhibition offered an unparalleled opportunity to bring innovative, international, cutting-edge design to Philadelphia. Lace itself became the common vocabulary for our selected artists and designers in the production of three commissions, demonstrating how the creative process can engage with an historical collection to result in dramatically new concepts.

The Design Center at Philadelphia University, home to over 200,000 historical textiles, holds a unique sampling from the Quaker Lace Company of Philadelphia (in operation from the 1890s to the 1990s) of some 150 textile swatches; 1,000 original sketches; and advertising ephemera. In keeping with its mission, the Center's textile collection is regularly used for educational programming and has been incorporated into interpretive exhibitions in the past. But never before has any one portion of the collection inspired an exhibition on such a grand scale.

The Quaker Lace artifacts presented an unprecedented occasion to marry the goals of promoting outstanding design and providing insight into the design process through the creative exploitation of the historical textile collection for current relevance. Lace in Translation bridges modern and historic design in a fresh take, providing an exemplar for professional artists, designers, and design students of all disciplines of the potential to employ historical sources to inspire the workings of the imagination. And not only does Lace in Translation focus on an international and national exchange with artists and designers using The Design Center's historical lace collection to create one-of-a-kind installations, the works simultaneously address some of the most compelling contemporary issues being fielded by product designers, artists, architects, landscape architects, and historians today.

This complex venture, from envisioning the scope of the project to bringing the exhibition, Website, video, and catalogue to fruition, elevated The Design Center's capacity to create challenging, captivating shows and expanded our curatorial practice. The Lace in Translation curatorial team — Carla Bednar, Assistant Director of The Design Center; Nancy Packer, the Center's Collections Curator; and myself — remained steadfast throughout the process.

I particularly want to acknowledge the generosity of spirit of those commissioned to create the site-specific installations. Each was clearly passionate about their assignment: Cal Lane and her 2,000 gallon oil tank and torched lawn in the back yard; Tord Boontje and his entwined indoor galleries; and Demakersvan with their 160 linear feet of Lace Fence sweeping up the front driveway. I am deeply thankful for the generous financial and sage support from the Philadelphia Exhibitions Initiative and Marketing Innovation Program of The Pew Center for Arts & Heritage, the Pennsylvania Council on the Arts, The Coby Foundation, Ltd., and Philadelphia University. Lace in Translation was a tremendous team effort. I wish to thank the many people who contributed their time, talent, muscle, and ideas, including the staffs of Hagley Museum and Library, and the Atwater-Kent Museum, and the students, faculty, and staff of Philadelphia University, with particular gratitude to the members of the Physical Plant Department. Thank you all.

HILARY JAY, *Director*

Top to bottom: Detail of Lace Fence (Demakersvan), spiderweb sofa (Tord Boontje), and oil tank (Cal Lane) for *Lace in Translation*, 2009.

STYLISHLY ARRAYED IN QUAKER LACES

Lace in the Quaker City

NANCY E. PACKER, *Collections Curator, The Design Center*

Lace. The word conjures visions of gossamer bridal veiling, dainty trim on a christening gown, frothy negligees, and exotic lingerie. Lace has sumptuously adorned the mansions of the wealthy, and modestly veiled the windows of the humble. It has spurred fashion, and looked to history; inspired paper doilies, and iron railings; symbolized wealth, and signified social climbing. Perhaps the most impractical of all fabrics, it flaunts fashion over function, and fragility over substance. As it veils, it also reveals, offering itself as a symbol of purity...and of sexual allure.

*L*ace in Translation offers new insights into this most variable of textiles. Featuring commissions by internationally renowned artists and designers inspired by the historical lace collection of The Design Center at Philadelphia University, the exhibition presents unexpected materials and technologies to reconceive conventional notions of lace; and it challenges the supposed dichotomy between traditional and contemporary design. In an age in which the boundaries of what defines a "textile" are stretched — when Kevlar helmets are made of woven carbon fiber and street lamps are constructed from woven fiberglass — *Lace in Translation* confronts customary notions of what lace is and how it functions: from a luxury fabric for the adornment of the body and the interior reserved for the privileged few, through its mechanization and dissemination to a mass consumer market, and on to its reconceptualization as a dramatic design element executed in a wide range of materials, for a potentially infinite variety of purposes.

> In an age in which the boundaries of what defines a "textile" are stretched — when Kevlar helmets are made of woven carbon fiber and street lamps are constructed from woven fiberglass — *Lace in Translation* confronts customary notions of what lace is and how it functions.

"LACING" THE SCHUYLKILL

The impetus for this project emerged from an unexpected convergence of ideas. A tour of Christo's and Jean-Claude's 2005 *Gates* in Central Park and the purchase of a lacy, laser-cut greeting card by designer Tord Boontje led to a lively conjecture about the possibility of creating a large-scale environmental and experiential installation that capitalized on Boontje's lacelike designs. While it was obvious that grand speculations about commissioning Boontje to drape the Schuylkill riverfront in lace weren't feasible, it did seem conceivable that we could invite the designer to interact with our gallery and grounds on the campus of Philadelphia University to create a site-specific installation on a lace-inspired theme.

Our next thought was how to involve The Design Center's collection, to make this project directly relevant to Philadelphia and the city's rich legacy of textile manufacturing. The concept held particular appeal at the time, as The Design Center was in the early stages of investigating the resources and potential audiences for a new initiative called The Fabric of Philadelphia, which seeks to gather and tell the many stories of Philadelphia's two-hundred-year history of textile manufacture. As part of the nation's oldest textile school (Philadelphia University was founded as the Philadelphia Textile School in 1884) and the repository of the University's historic textile collection, the Center preserves significant holdings from the days when Philadelphia was at the pinnacle of the nation's textile design and manufacturing.

The obvious solution was to use a collection of artifacts from the Quaker Lace Company of Philadelphia. An industry leader in machine-made lace for much of the twentieth century, the collection includes dozens of machine-made lace samples, company marketing brochures, and glass slides depicting Quaker Lace products in household interiors. The collection, donated largely by Ruth and Eric Vessey three decades ago, also includes hundreds of original sketches by the Vesseys' ancestor and Quaker Lace's head designer at the turn of the century, Frederick Vessey (1862–1948), who was lured to Philadelphia from Nottingham, England, to work in America's burgeoning lace industry and brought with him lace-making machinery and skilled lace weavers. While often overlooked by researchers interested in older, handmade laces, the Quaker Lace collection illuminates a period of dramatic change in American social and industrial history, as mechanization offered middle-class Americans the novel opportunity to adorn themselves and their homes with what was previously a luxury item. The fit of Boontje's design sensibility with the Quaker Lace Company collection also was ideal, given the Philadelphia firm's application of the new technologies of the late Victorian era to reproduce the elaborate hand-crafted laces of earlier centuries. Boontje similarly seeks to evoke the expensive, hand-wrought finishes of old through modern industrial materials and techniques.

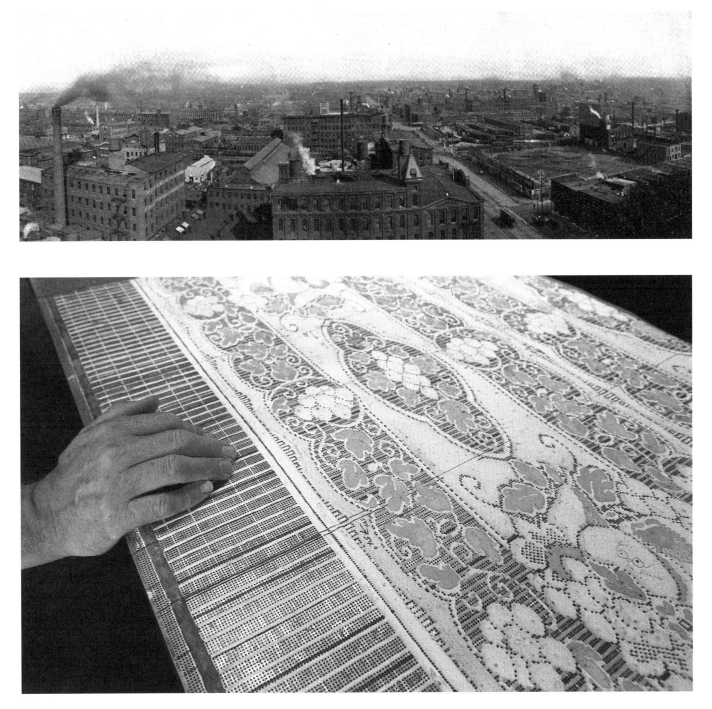

Top: View of the Kensington neighborhood manufacturing district from the roof of the Joseph H. Bromley (Quaker Lace) factory, ca. 1900. Collection of The Design Center at Philadelphia University.

Above: Detail of machine-made lace punch card pattern, photograph taken at the Quaker Lace factory, Philadelphia, 1992. Courtesy of Hagley Museum and Library.

Facing page: Fairy Tail greeting card, Tord Boontje for Artecnica (2003).

Page 6, background: Detail of sketch by Frederick Vessey for Quaker Lace, pencil on paper, ca. 1890–1910.

Page 6, inset: Illustration from the *Quaker Lace Book* for 1914, Philadelphia. Collection of The Design Center at Philadelphia University, gift of Ruth and Eric Vessey.

Page 7: Sketch by Frederick Vessey after A. Forkel, watercolor and ink on paper, Nottingham, England, 1894. Collection of The Design Center at Philadelphia University, gift of Ruth and Eric Vessey.

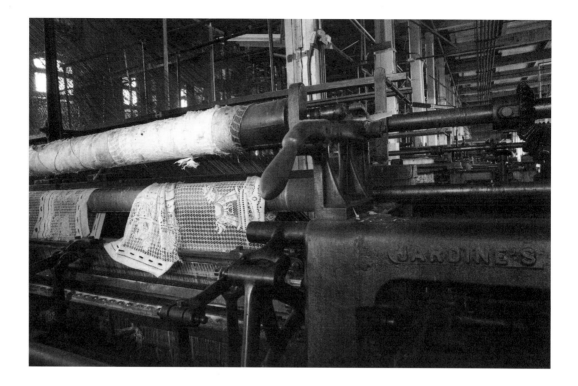

With our focus fixed on the Quaker Lace collection, the *Lace in Translation* concept started to take form, and we began to seek out other innovative designers and artists who incorporate traditional lace imagery while using unconventional materials and processes. In 2007, Boontje, the Dutch design team Demakersvan, and Canadian sculptor Cal Lane were invited to The Design Center to explore its lace collection for potential inspiration and to consider how their work might interact with the Center's interior and exterior environments. Like lace itself, the Center's siting both hides and reveals the building, which was constructed in the mid-1950s as a private house. The entrance is shielded from public view by a white brick wall, which serves as a visual buffer and sound barrier, and is revealed only as the visitor progresses up a curving driveway. By contrast, the Center's galleries are visually open to the backyard, with floor-to-ceiling, wall-to-wall windows extending sixty-five feet along the rear façade. *Lace in Translation* exploits these features of site and structure to promote a dynamic discourse about the role in contemporary design of public and private, old and new, craft and industry.

While there has been renewed interest in re-examining traditional knotted textile structures like lace, this project was unique in dictating a specific creative starting point. Not merely an assemblage of individual artistic statements, *Lace in Translation* posed the contributors a particular question — how might a collection of historical lace be harnessed and reworked to inject its textures and sensual qualities into the designed environment? Even as Quaker Lace designer Vessey turned to traditional, handmade lace from the Netherlands, Germany, France, and Belgium for inspiration, the designs he produced have in turn informed the creative concepts of Lane, Boontje, and Demakersvan. As the machines of Quaker Lace once translated the deft fingerings of lacemakers into the "complex, rapid and intricately synchronized movements of...metallic parts," this project pushes the concept of lace further still, utilizing unexpected materials and new technologies to transform interior and exterior spaces, and to challenge traditional concepts of what lace is and how it functions.[1]

"A WRESTLER IN A TUTU"

Demakersvan, Boontje, and Lane were chosen for this project for their internationally recognized achievements in creating groundbreaking visual experiences by combining historically and organically derived design elements with cutting-edge production and fabrication techniques. Each explores the interaction of the tactile qualities of craft with the functionality of modern materials and mass-production, and challenges conventional dichotomies of feminine and masculine, organic and industrial, and beauty and functionality. The Demakersvan team and Tord Boontje are product designers, who envision reshaping the built environment through the creation of well-designed products that can be mass-produced and disseminated to a broad audience, while maintaining their sensory appeal. In intriguing counterpoint, artist Cal Lane takes used, mass-produced, everyday objects like dumpsters, wheelbarrows, shovels, and oil tanks and radically transforms them, challenging audiences to reconsider their responses to these seemingly unappealing artifacts.

The Rotterdam-based Demakersvan team — comprising Eindhoven Design Academy graduates Joep and Jeroen Verhoeven and Judith deGraauw under a name that means "the makers of" — spells out its philosophy as "a respect for the old, but a want of the new. We want to challenge, confront the normal, the accepted, the expected." A deep interest in surfaces informs their work, as they seek to achieve the enduring quality of handcrafted goods in affordable, accessible design. Like Quaker Lace designer Vessey, they envision the intersection of machine production with good design and high quality: "we have to see to it that machines start working for us again, instead of allowing ourselves to be led by them."

> We have to see to it that machines start working for us again, instead of allowing ourselves to be lead by them.

Demakersvan confronts the visual impact of human modification and cultivation of the environment, likening industrial fencing to "brambles ...rising rampantly around us." Their answer to that design conundrum was the Lace Fence, first conceived of by Joep Verhoeven for his senior project at Eindhoven. Incorporating organic, bobbin-lace motifs into functional steel chain-link fencing, the Lace Fence challenges visual "hostility" with "kindness." Demakersvan demonstrated particular interest in the filler motifs of The Design Center's Quaker Lace samples, selecting designs that feature organic forms which visually break the rigid rectangular field of the sample. They considered a wide range of settings for a Lace Fence installation, and decided ultimately on the Center's curving front drive, deeming its round curves "friendly and poetic," and suited to the rounded organic forms rendered in metal lace. They were enthusiastic about the visibility that such a dramatic structure in the environment would offer the Center. They predicted that the Lace Fence would "make people curious and enthusiastic to see what's inside" whether walking or driving by.[2] For The Design Center, the Lace Fence represents a unique opportunity to present visitors with a dramatic statement of identity upon entering the grounds. Incorporating imagery derived from an early-twentieth-century Philadelphia textile, the Lace Fence meshes the diverse interests of the Center, as a collecting institution focusing on historical textiles and Philadelphia's textile heritage, and an exhibiting institution devoted more broadly to contemporary design and design issues.

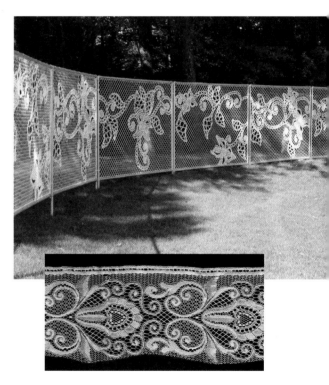

Top: Lace Fence installation at The Design Center, 2009.

Bottom: Cotton machine-made lace sample used by Demakersvan as inspiration, Quaker Lace Company, Philadelphia, early 20th century. Collection of The Design Center at Philadelphia University, gift of Ruth and Eric Vessey.

The internationally renowned designer Tord Boontje defines his design philosophy as: "a belief that modernism does not mean minimalism, that contemporary does not forsake tradition, and that technology does not abandon people and senses." Like Vessey a century ago, Boontje combines craft and mass production sensibilities in his products and aims to achieve the luxurious surfaces of historical objects, often painstakingly and expensively achieved, through innovative industrial techniques. Much of his previous work has utilized cut-out processes to create delicate, lacelike effects in metal and fabric. This project pushed that concept of openwork further, inspiring him to experiment with a process that was novel for him — that of bobbin lace-making, which involves the intertwining construction of yarns. Boontje, however, sought to move beyond the conventional lace-making fibers of fine linen and silk. Working from his studio in the remote French countryside, he was inspired by the nature he saw around him: foliage, grasses, bark, spiderwebs. He even recorded his family watching with fascination the daily web building that went on for months outside a window of their home. From these encounters emerged the narrative underpinning of his installation, which he describes as "something very romantic...a girl from the country is going to a party and has nothing to wear but she has got some straw, a Hollywood magazine, and an ability to make things by hand."

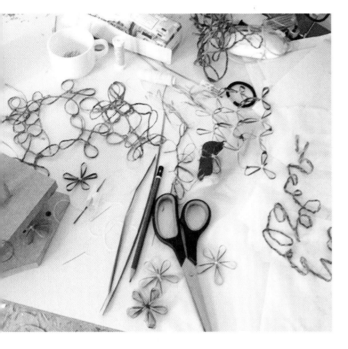

Tord Boontje defines his philosophy as: "a belief that modernism does not mean minimalism, that contemporary does not forsake tradition, and that technology does not abandon people and senses."

Boontje's installation also manipulates natural and artificial light to emphasize and veil the patterns captured within the lace, and to elicit responses to light and dark, revelation and secrecy, purity and mystery. One gallery is dressed completely in black lace, yielding an atmosphere that plays on lace's association with concealment and mystery. Hidden inside the shadows and fabrics are a vast weblike sofa by Boontje and antique lace garments from the Center's collections, conjuring the designer's fascination with the "spectral ghosts of dark tales and darker corners of human experience [that] haunt...the spaces and the objects of the everyday."[3] In complete contrast, two rooms away is a gallery bathed in white, referencing lace's traditional association with purity and romance, as seen in wedding veils, christening gowns, and girls' dresses. Here Boontje has installed samples of his exploration of lace construction principles in three-dimensional form in grasses, raffia, and string. The room evokes the familiar pristine setting of a white-cube museum, the effect softened by rip-stop fabric panels laser-cut into bark-like patterns. Between lies a gallery of gold, contrasting the sheen and glamour of gilt walls with a gown, headdress, jewelry, and chandeliers woven of raffia and grasses, materials he selected in part because they are typically accorded little value in the West, but play significant roles in many other world cultures. A vast raffia lace curtain, hand-made by co-curator Carla Bednar with the assistance of Philadelphia University students and faculty, references that most ubiquitous of machine-made lace goods and Quaker Lace's signature product, the lace curtain, even as Boontje's design turns that reference on its ear through hand construction and his unexpected choice of material.

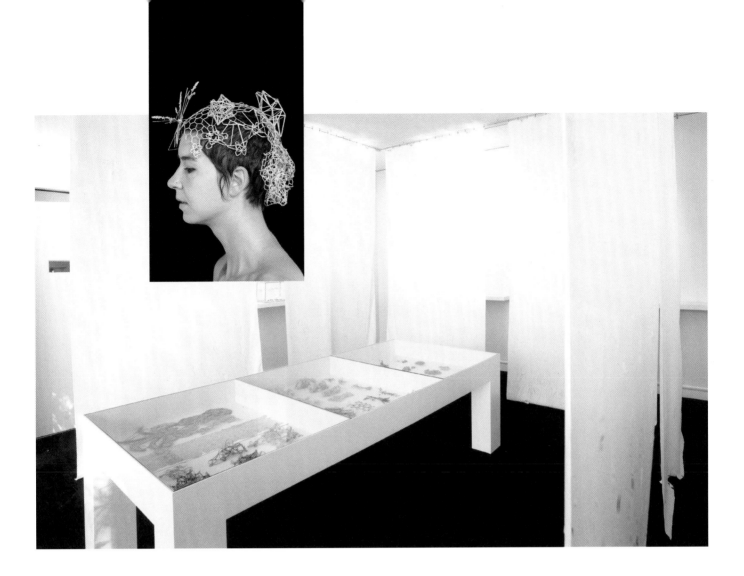

Above: Gallery view, *Lace in Translation* with grass and raffia lace samples, laser-cut Trevira CS fabric panels, and furniture maquettes, Tord Boontje, 2009.

Inset: Grass hair piece for *Lace in Translation*, Studio Tord Boontje, 2008.

Far left: Detail of raffia lace curtain, The Design Center, 2009.

Left: Bobbin lace-making with grass at Studio Tord Boontje, Bourg Argental, France, 2008.

Facing page: View of grass lace sample-making in progress at Studio Tord Boontje, Bourg Argental, France, 2008.

Venetian
Point à Réseau
late XVII

Lane came to her interest in lace as a tongue-in-cheek way of questioning femininity in the traditionally masculine field of welding.

Keep insides—Make a Reflection on ground

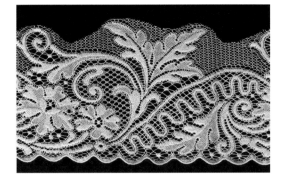

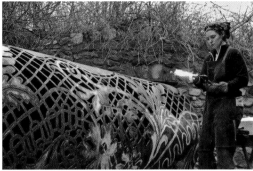

Above: Illustration from *Quaker Craft Lace*, ca. 1920. Collection of The Design Center at Philadelphia University, gift of Bethany Herman.

Top left: Cotton machine-made lace sample used by Cal Lane as inspiration, Quaker Lace Company, Philadelphia, early 20th century. Collection of The Design Center at Philadelphia University, gift of Ruth and Eric Vessey.

Top right: Cal Lane creating oil tank for *Lace in Translation*, Putnam Valley, New York, 2009.

Facing page: Detail of sketch of Venetian Point à Réseau, Frederick Vessey, pencil on paper, ca. 1890–1910. Collection of The Design Center at Philadelphia University, gift of Ruth and Eric Vessey.

Inset: Preliminary watercolor sketch for oil tank, Cal Lane, 2008. Courtesy of Cal Lane.

Visible through the raffia lace motifs is the dramatic installation of Canadian-born sculptor and welder Cal Lane. For Lane, who considers herself a "visual devil's advocate," the contrasts and contradictions in her work help to tease out an image that balances, even as it clashes. The 2000-gallon oil tank that she arc-cut and hand-patinated into a delicate filigree directly inspired by a Quaker Lace sample for *Lace in Translation* exemplifies these contradictions. Celebrating and complicating notions of industry and art, feminine and masculine, creation and destruction, the six-hundred pound tank had to be crane-lifted high over the Center's roof and set to rest, seemingly lightly, on the cover of the 1950s in-ground pool. Lane's installation also plays with traditional graphic processes, like stenciling, printing, and intaglio carving: she torched a lacy pattern into the grass of the lawn and arranged the welded fragments of the oil tank so they could form their own rusted imprints.

Lane came to her interest in lace as a tongue-in-cheek way of questioning femininity in the traditionally masculine field of welding — laying lace doilies on the equipment in the metal shop at the end of her work day. The unexpected juxtaposition led her to start exploring the comparison and contrast of ideas and materials in her work, including traditional ideals of "industrial and domestic life,...relationships of strong and delicate, masculine and feminine, practicality and frivolity, ornament and function." She was intrigued by the use of lace in religious ceremonies and cultural rites of passage, such as weddings, christenings, and funerals, and by its inherently contradictory but contemporaneous use to both hide and expose: "like a veil to cover, or lingerie to reveal." Her work features recovered, mass-produced steel tools and industrial products — dented and corroded wheelbarrows, I-beams, and oil drums — that she arc-welds into lacy echoes of their former forms. Despite their association with power and strength, no more than a gentle rain is needed to return these hardened steel structures, over time, to their natural state.

For the *Lace in Translation* project, Lane was struck by the parallels between her theorizing and the concepts advanced by Quaker Lace marketing materials in the early twentieth century, which defined windows as "the eye of the house" and praised lace's capacity to both conceal and expose, to soften and screen. As one 1920 brochure remarked, "The dual character of the window demands...a window covering which will also have dual characteristics. [It]...must effectively shut off the gaze of the curious passer-by; yet looking through it you should get an unobstructed view of the life of the streets or the beauties of the country."[4] Seen from inside the scrim of raffia and machine-made lace curtains in the Center's galleries, Lane's oil tank and torched lawn similarly play on themes of solids and voids, creation and destruction, decoration and decay, ornament and the everyday, and personify the artist's desire to inject "humor through...unexpected relationships,...like a wrestler in a tutu."

NATURE IN A NET

The fabric at the heart of this exhibition — lace — is often closely associated with tradition. Yet lace has had a dramatic and diverse history, often defining fashion in its wake. Human fascination with open-work fabrics dates back thousands of years, as evidence for experiments with knotted, braided, drawn-work, and open-weave techniques have been found in garments and archaeological fragments from cultures as diverse as ancient Egypt and Rome, Bronze Age Europe, and pre-Columbian Peru. The impetus for such fabrics may date even further back, to prehistoric peoples' needs for nets and snares for hunting and fishing. In fact, the modern term "lace" owes its origins to the Latin *laqueus*, meaning noose or snare — a connotation that still survives today in the English word *lasso*. But only over the last five hundred years have humans successfully trapped nature in a net — creating intricate geometric grounds of intertwined linen, silk, metallic, or cotton fibers, in which increasingly elaborate representations of flowers, shells, insects, animals, and human figures have become gracefully ensnared.

It was against the turbulent background of sixteenth-century Europe — an era of religious and dynastic warfare, economic growth and turmoil, and overseas exploration and colonization — that lace and fashion emerged hand-in-hand.[5] In this tumultuous environment, in which power and status were under constant threat even at the highest strata of society, it is not surprising that lace, along with other luxury fabrics, became a highly visible symbol of social rank. The massive tiered "millstone" ruffs of the Elizabethan court exemplify lace's quick rise in the fashion of the era. Restricted to royalty and the nobility by both sumptuary laws and expense, these elaborate structures flaunted the outlay of money on labor and yardage in their construction, as well as the extraordinary care in laundering, starching, and pressing needed to keep them at their showy best. Yet they functioned solely to ornament and distinguish their wearers.

Although these fantastic edifices of lace would soon fall from fashion, lace increasingly appeared elsewhere on the fashionable body in the seventeenth century — on draped collars and crisply filigreed cuffs on both men's and women's garments, flamboyant handkerchiefs and decorative aprons, even brimming from the cuffs of gentlemen's boots. Lace was an ideal expression of Baroque opulence, seen at its ostentatious best in the

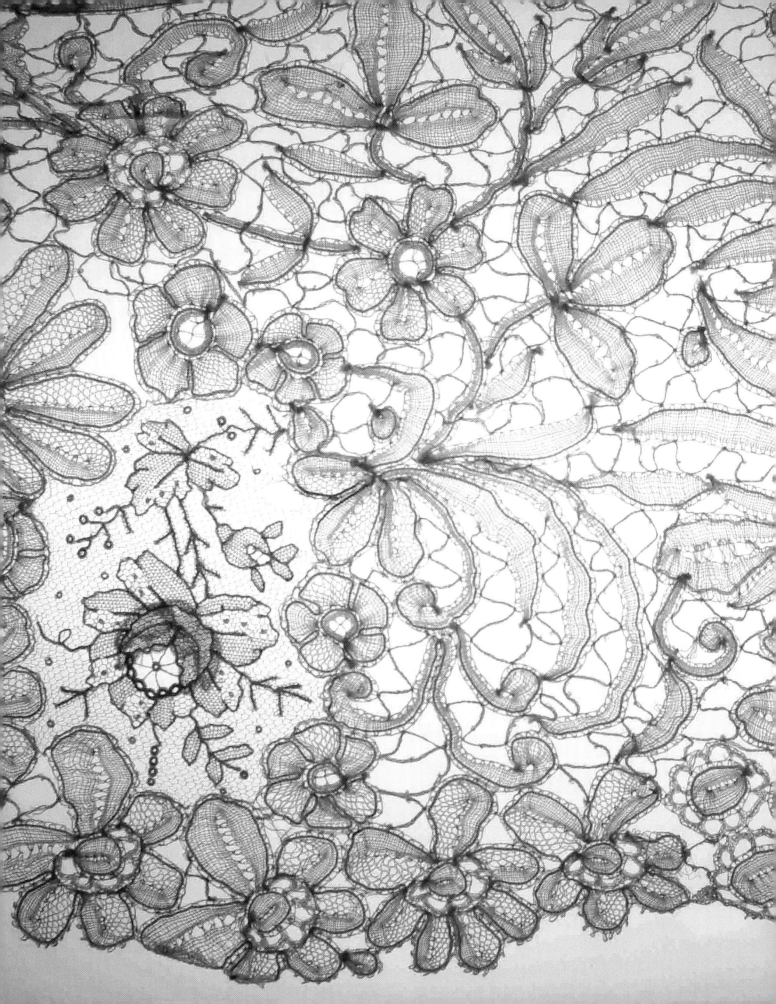

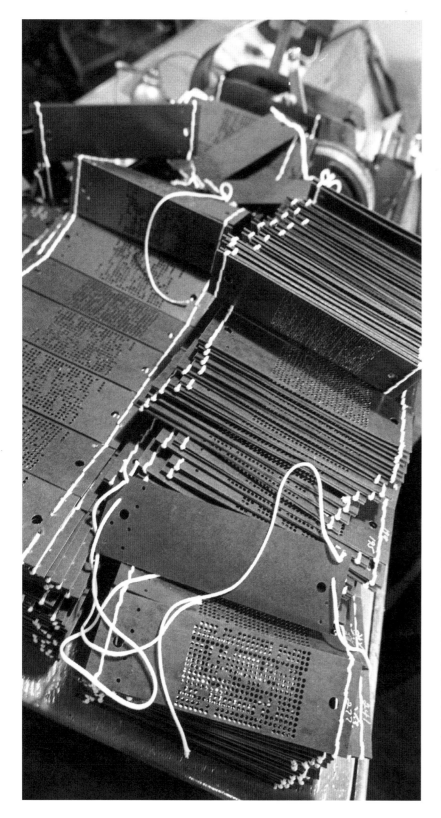

lavish courts of Charles II of England and Louis XIV of France. The growing demand for lace in virtually all elements of men's and women's fashions, along with rising wealth and the emergence of an affluent bourgeoisie, stimulated regional lace industries throughout Europe and fostered the development of the most exquisite Italian needle laces and Flemish bobbin laces. Yet fashion began to turn away from lace in the next century, as the mindset of the Enlightenment cultivated a simpler and more rationalized approach to dress. While filmy froths of lace continued to adorn caps, necklines, sleeve ruffles, and cravats, lace as a status symbol yielded pride of place to the magnificent brocaded silks of the eighteenth century. The trend toward democratization in society increasingly was mirrored in fashion, and the taste for the simple lines of Grecian-inspired, Neoclassical garb at the end of the century called for only the plainest of net trims. Not until the return of lavish ornament in the Victorian era combined with the mechanization of lace-making did lace make a full return to the forefront of fashion.

It was in England, that hotbed of mechanical innovation in the eighteenth century, that the industrialization of lace-making finally was worked out. The first successes in this endeavor materialized in the years surrounding the American Revolution, when entrepreneurs and inventors around Nottingham began to experiment with adapting the stocking knitting frame — invented there three centuries earlier — to create lacelike fabrics. The resulting silk netting (or "point net") enjoyed immediate popularity, but its basic looped structure, derived from the knitting technique, made it fragile and liable to be easily unraveled, while elaborate patterning on the net still required skilled hand work. Not until the bobbin-net machine was patented and further refined in the early nineteenth century did a twisted net fabric that more closely replicated the structure of true bobbin lace emerge, although some elements of the design still had to be applied by hand. In a decade of furious invention that began in the 1830s, jacquard technology was applied to lace-making and ultimately yielded a range of machines that could successfully imitate patterned handmade laces. Essentially an ancient ancestor of the computer, the jacquard loom used hundreds or even thousands of punched cards to control the placement of each thread in a complexly patterned textile. The invention of the Nottingham lace curtain machine in the 1840s enabled even greater variety in lace design, permitting a wide range of textures and densities that were particularly effective when displayed against a window. A behemoth up to forty feet long and weighing fifteen tons or more, the new contrivance nevertheless could achieve much

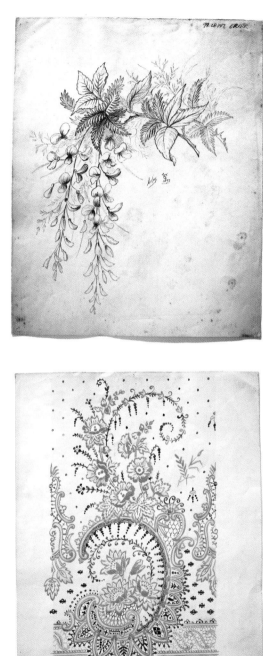

Top: Nottingham lace curtain machine, ca. 1890, Quaker Lace Company, Philadelphia, photograph taken 1992. Courtesy of Hagley Museum and Library.

Above: Detail of lace sample made on the first lace curtain machine in America, cotton, Wilson and Willoughby, Fordham, NY, ca. 1885. Collection of The Design Center at Philadelphia University, gift of Ruth and Eric Vessey.

Top right: Sketch by Frederick Vessey, pencil on paper, Nottingham, England, 1893. Collection of The Design Center at Philadelphia University, gift of Ruth and Eric Vessey.

Bottom right: Sketch by Frederick Vessey after A. Forkel, watercolor and ink on paper, Nottingham, England, 1894. Collection of The Design Center at Philadelphia University, gift of Ruth and Eric Vessey.

Facing page: Jacquard punch cards for lace curtain machine, Quaker Lace Company, Philadelphia, photograph taken 1992. Courtesy of Hagley Museum and Library.

of the delicate shading and detail of handmade laces through the manipulation of tens of thousands of threads — the mechanical equivalent, perhaps, of a wrestler making a tutu.

The new technology permitted machine-made laces to closely copy virtually any example of handmade bobbin lace, and manufacturers eagerly replicated every style they could find, without regard to origin or date. As a result, the whole universe of regional European lace variations quickly became accessible to the Victorian consumer. The availability of this vast range of styles and designs was well suited to the period's tastes for encyclopedic collecting, the accretion of things, and the near obsessive mining of other cultures and eras. In America, where commercial lace-making had not been successfully established in the era of handmade laces, consumers were particularly free to adopt any combination of styles, with no competition from pre-existing regional traditions of lace-making.

The lavish products of the Nottingham lace curtain machine were conspicuously displayed at the great expositions of the era, including the Centennial Exposition in Philadelphia in 1876, and Americans became eager consumers. A rapidly growing middle class fueled a housing boom after the Civil War, and this spawned a stylistically diverse stock of houses united by their prominent and abundant use of windows. Lancet windows on a Gothic Revival cottage, arched dormers on a Beaux Arts mansion, floor-length sash windows on a Queen Anne farmhouse, or a projecting bay on an Italianate villa — all were opportunities for consumption and display, and American manufacturers were keen to meet the demand. Importing the massive Nottingham lace looms from England, along with the workers to run them and designers to fashion their products, American firms in the late nineteenth century quickly established themselves as worthy competitors in the thriving, but volatile, international market for lace.

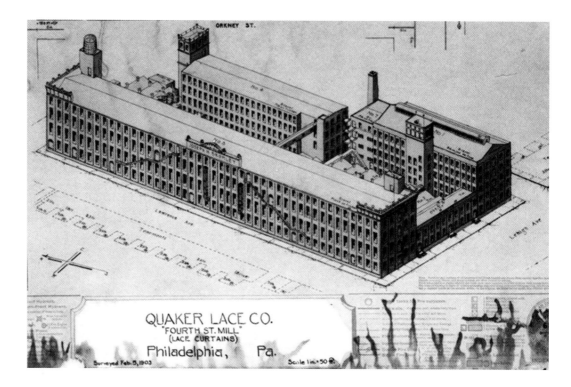

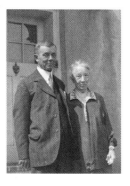

THE ART OF EMPTY SPACE

In Philadelphia, it was the lace mills of the Bromley family that dominated the local trade. Descendants of an immigrant carpet weaver from Yorkshire, England, the Bromleys were a prominent force in Philadelphia's thriving textile industry for more than a century and a half. The sons and grandsons of John Bromley heartily embraced the machine-made lace industry, founding a range of lace mills and firms in the late nineteenth and early twentieth centuries. The longest-lived and most successful of these ventures was Quaker Lace, which began life in the mid-1890s as the Lehigh Manufacturing Company in the former Horner Brothers carpet mills, located at the intersection of Fourth and Lehigh Streets in Philadelphia's Kensington neighborhood. To the Horner Brothers' existing twenty-one Nottingham lace curtain looms, Joseph Bromley added more than eighty, each purchased from England at the considerable cost of $4,000 apiece.[6] By 1903, the Fourth and Lehigh mill, already known as Quaker Lace (although that name would not be incorporated until 1911) filled the entire city block with four- and five-story buildings that housed facilities for all the activities necessary to make lace, from drafting and designing, to spooling, reeling, and weaving, to bleaching, finishing, drying, and mending.

One of the most compelling components of the Quaker Lace collection at The Design Center are the pencil sketches and gouache drawings of the company's chief designer in the late nineteenth and early twentieth centuries, Frederick Charles Vessey. Born in Nottingham in 1862, at the height of innovation in lace-making machinery, lace was in Vessey's genes. His great-uncle, Charles Willoughby — a Nottingham lace manufacturer with a small factory of hand-powered lace-making machines — manufactured the prize-winning lace curtain at the Philadelphia Centennial Exhibition and, in 1885, introduced the first Nottingham lace curtain machine in the United States at his new factory in Fordham, New York. At the tender age of 18, his great-nephew Frederick was already working as a "draughtsman," tracing lace designs onto graph paper in preparation for their transfer to punched cards, and a decade later, he appeared in the 1891 census of Nottingham as "Curtain Draughtsman." It may have been Willoughby's presence in the United States by this time that brought Vessey to the attention of the Bromleys. At their urging, with his large and growing family in tow, Frederick Vessey arrived in Philadelphia on the Fourth of July, 1897.

> This art of empty space — which requires a keen sensitivity to voids and to solids — is essential to the design of lace. It also is what unites Vessey with his contemporary interpreters.

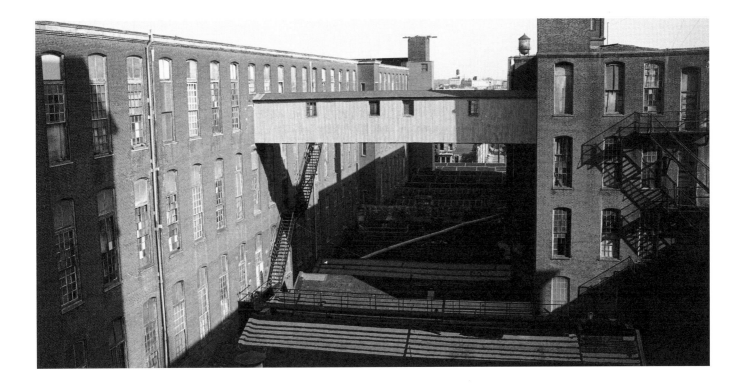

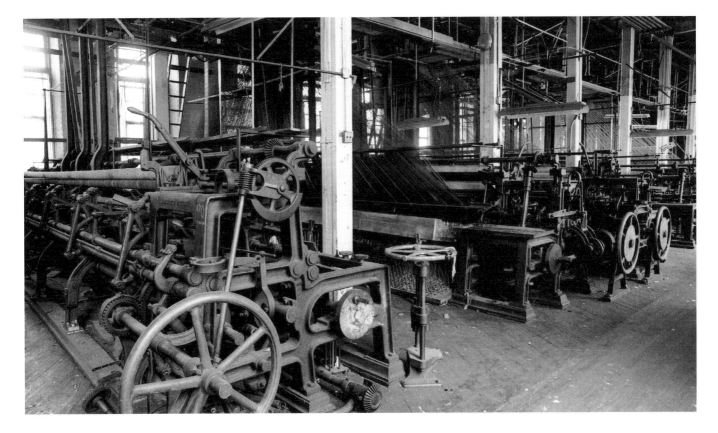

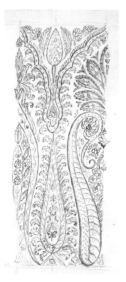

Above and right: Sketch of paisley shawl by Frederick Vessey, pencil on paper, ca. 1890–1910, and paisley-patterned machine-made lace sample, cotton, Quaker Lace Company, Philadelphia, early 20th century.

Bottom right: Sketch by Frederick Vessey, gouache on colored paper, ca. 1895–1900. All collection of The Design Center at Philadelphia University, gift of Ruth and Eric Vessey.

In an intriguing counterpoint to the creative process of the contributors to this project, who turn to history for inspiration, Vessey himself mined such varied sources as Egyptian tomb paintings, Jacobean architectural motifs, and tin ceiling catalogs to inform his designs for the Quaker Lace product line. Compiling a vast library of images of historical laces, textiles, painting, sculpture, architectural ornament, and metalwork, Vessey drew inspiration from the fine and decorative arts of past ages in his designs for Quaker Lace, as he sought to enrich the environment of contemporary consumers. In characteristic Victorian fashion, his designs served as a kind of museum of ornament for the education of the company's consumers, allowing middle-class Americans to indulge in the grandeur of Rococo France, the richness of the Ottoman Empire, and the glory of ancient Rome.

But Vessey's sketches do more than merely reveal a personal aesthetic that was encyclopedic. His drawings also yield rare insight into the age-old technique of lace design, whether that design ultimately was executed by hand or machine. Vessey demonstrated an extraordinary capacity to isolate individual design elements from their surrounds, whether that element was a French gilt looking glass, a segment of interlaced frieze from the Alhambra, or a hunting scene wrought in low relief on a grand silver platter. He then created a new setting for these motifs, uniting them with other elements through a fine interlacing of mesh or net. This art of empty space — which requires a keen sensitivity to voids and to solids — is essential to the design of lace. It also is what unites Vessey with his contemporary interpreters, be it Demakersvan linking bobbin-lace motifs and common fencing, Tord Boontje weaving a fine network of grasses to both shade and reveal light, or Cal Lane torch-cutting steel into a delicate tracery of metal.

CORRECT CURTAINS

Vessey's felicity in the art of empty space stood Quaker Lace in good stead. The company quickly surged to the forefront of the American market in the early twentieth century and, with other American manufacturers, even began to challenge England's pre-eminence in machine-made lace.[7] A new and larger factory at 22nd Street and Lehigh Avenue in Kensington was touted by the company as "the largest and most modern lace plant in existence," and "one of the sights of the Quaker City."[8]

Creative marketing also was critical to the firm's success. In 1912, Quaker Lace began to issue a series of style books that introduced retail consumers to the company's products and their potential uses in both

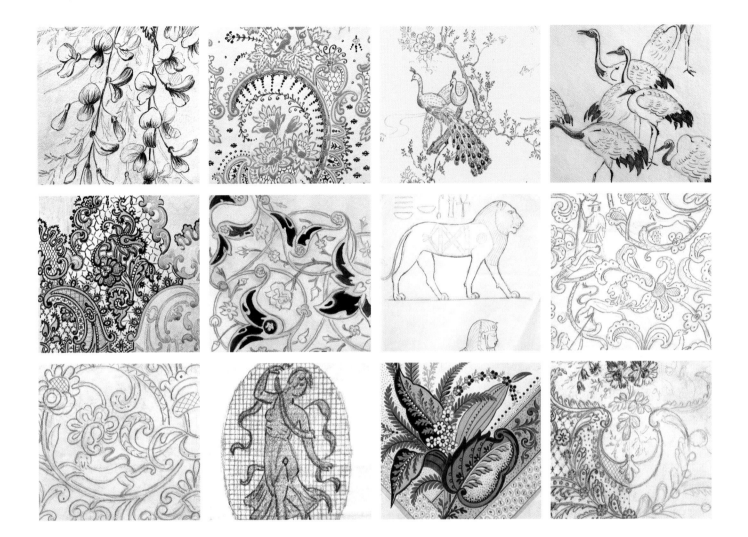

Above: Details of sketches and lace designs by Frederick Vessey, watercolor, gouache, ink, and pencil on paper, Nottingham, England, and Philadelphia, ca. 1890–1920. All collection of The Design Center at Philadelphia University, gift of Ruth and Eric Vessey.

fashion and household ornamentation, and opened a showroom in New York, where both individuals and commercial clients could examine and purchase the company's latest offerings. Retail consumers could also obtain Quaker Lace products through a vast network of the nation's leading department stores from coast to coast. By 1916, the company employed twice the proportion of sales staff as any of its local competitors.[9]

The firm's marketing materials both evoked the "romance" and "richness" of lace for potential consumers and provided guidance to negotiate the bewildering array of available designs and products. Seeking to capitalize on the "Era of Lace" in Edwardian women's fashion, early brochures proffered fashion-conscious females advice on how to utilize lace trims in stylish and appropriate ways, on gowns, coats, hats, lingerie, and more. "No part of a

woman's wardrobe" they declared, was complete "without [its] allotment of rich lace." Similarly, socially aspiring homeowners were reminded that a Quaker curtain "proclaims to the public that people of taste live within." "Cheap curtains," by contrast, suggested "cheap people." With names like Flemish Flounce, Carickmacross Edge, Flemish Crochet, and Filet Venise, the firm linked its products to a romantic past, and appealed to a growing middle class seeking elegance and status. In *Correct Curtains and How to Select Them*, author Dorothy Ethel Walsh lauded the happy coincidence of central heating and lace curtains and played to her readers' complacence with living in a superior age, marveling that "not even the palaces of royalty could have, a hundred years ago, the ordinary, almost unrealized comfort of the average home of today."[10]

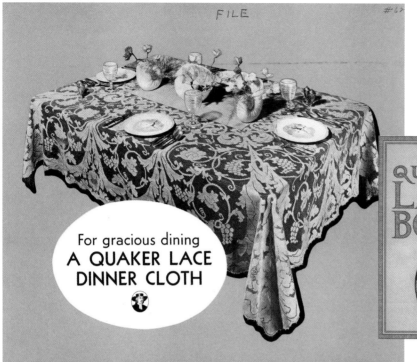

For gracious dining
A QUAKER LACE DINNER CLOTH

The vast range of designs and materials available gave consumers an opportunity to assert their individuality and personal tastes. Yet that same variety presented buyers, many of them novices to the fashionable use of this previously luxury fabric, with a dilemma — how to negotiate the bewildering range of styles, laces, and periods? The social anxiety inherent in the choice was explicit: "Haven't you noticed the windows of the homes you pass by? Remember, so do other people look at yours!" Quaker Lace primers like *Correct Curtains* were the answer, offering inexperienced or overwhelmed consumers practical instruction in the styles and designs "appropriate" to different settings. For example, to achieve "that much desired homespun look" of a "Colonial" room, they recommended "an exquisite filet net showing quaint 'Sampler' figures." By contrast, Tuscan net — a "heavy, coarse-meshed virile net" — was suggested for "heavy, rugged rooms" like dens and men's bedrooms. They also suggested a range of other ways to use Quaker Laces in the home — as table scarves, lampshades, and tea cozies — and responded to consumers' growing concerns about practicality, with the disappearance of the domestic servant after World War I. The company's brochures thus touted the technical features of Quaker Lace nets that allowed them to resist pulls, stretching, and distortion after washing, without losing that essential quality of transparency.

THE QUAKER LACE BOOK

Above: Marketing image for Quaker Lace tablecloth, 1938. Courtesy of Hagley Museum and Library.

Inset: *The Quaker Lace Book*, Quaker Lace Company, Philadelphia, 1913. Collection of The Design Center at Philadelphia University, gift of Ruth and Eric Vessey.

Right: Dorothy Ethel Walsh, *Correct Curtains and How to Select Them*, Quaker Lace Company, Philadelphia, 1926. Collection of The Design Center at Philadelphia University, gift of Ruth and Eric Vessey.

Below: Marketing image for Quaker Lace nets, featuring Hollywood actress Fay Wray, 1938. Courtesy of Hagley Museum and Library.

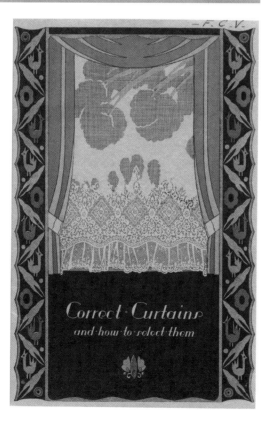

Correct Curtains and how to select them

THE CURTAIN FALLS

By the second quarter of the twentieth century, however, the fortunes of the lace industry nationwide began to falter, and Quaker Lace's with them. The slick modern look that emerged in design and architecture after World War I was at odds with the frothy, historicist, swaths of lace that had dominated the previous decades. While Quaker Lace sought to convince their customers of the continued desirability of lace for the fashionable home, featuring stylish women gazing through elegant lace-veiled windows in their marketing brochures, the heyday of the lace curtain was rapidly waning. Quaker Lace sales declined precipitously in the late 1920s, accompanied by a shrinking payroll. The Great Depression dealt a further blow, and the salaries of even experienced designers (Vessey was now retired) sank, not to recover for years.

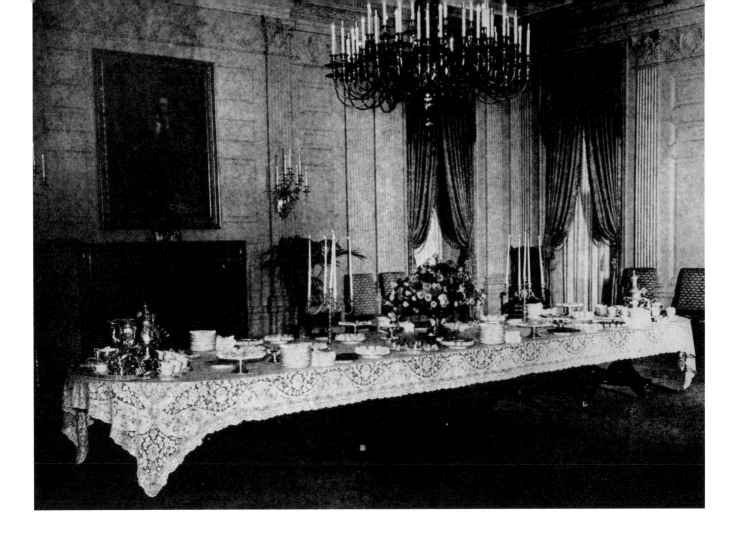

Demonstrating a continued talent for adaptability and innovation, Quaker Lace soldiered on. Lace tablecloths joined the product line in the early 1930s and quickly became the company's new signature product. Savvy marketing in the 1930s emphasized the "glamour and romance" of lace tablecloths, while a 1938 promotional campaign touted the use of "Quaker Nets" in the homes of Hollywood stars, including Fay Wray of *King Kong* fame. The firm also sponsored annual window dressing competitions in the 1930s during "Quaker Craft Week," awarding prizes for the most creative and visually appealing displays of Quaker Lace products at the nation's major department stores. Like other American lace companies, Quaker Lace retooled to meet government needs for camouflage and mosquito netting during World War II, while it continued to solicit the retail consumer through the introduction of new decorative motifs on household goods, including patriotic anchor motifs on curtain nets and modern "Hawaiian" tablecloths. A commission from the Eisenhower White House for a lace tablecloth — "the largest ever made on any machine in the United States" — gave the company another promotional boost in the early 1950s.

Even the flexible Quaker Lace, however, was not immune to the seismic shifts in the American textile industry in the second half of the twentieth century, with competition from cheaper technologies and fabrics, the shift to overseas production, a growing taste for easy-care synthetic fibers, and dramatic changes in the retail landscape. Innovative marketing helped the firm weather the recession of the 1980s, including licensing deals to reproduce early lace patterns for the Smithsonian Institution and Metropolitan Museum of Art, while the production of theatrical scrim was another viable market. The firm's development of a chemical process that allowed its tablecloths and curtains to withstand dozens of launderings without losing their shape also contributed to Quaker Lace's continued survival in an atmosphere in which easy care was increasingly essential, as American women became ever more present in the nation's workforce.

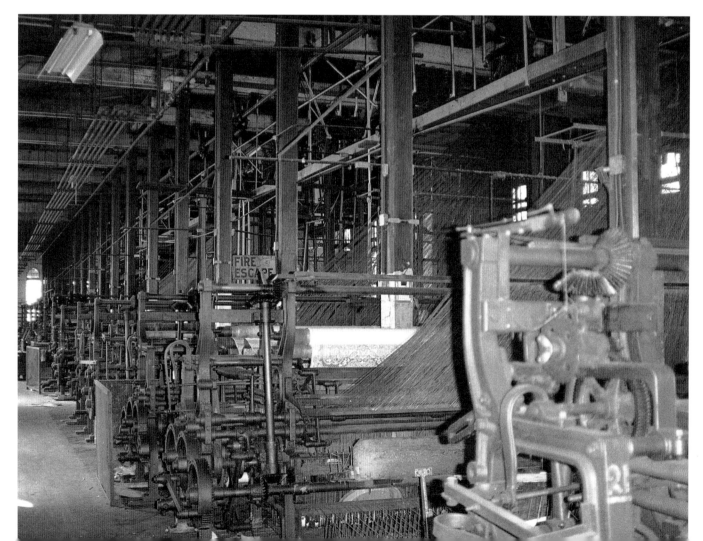

Below: Detail of the factory at Fourth and Lehigh, Philadelphia, before its destruction by fire, photograph taken 1992.

Facing page: Above: View of the mending room, and below: lace curtain machines at the Quaker Lace factory, Philadelphia, 1992. All courtesy of Hagley Museum and Library.

But by the late 1980s, the massive Nottingham lace looms at the Fourth and Lehigh factory fell silent, as manufacturing moved to plants in Chester County, Pennsylvania, and Winthrop, Maine. The Philadelphia mill continued to be the center for bleaching, dyeing, cutting, and packaging of the world-famous Quaker Lace tablecloths and curtains, and many Kensington-area residents, including the neighborhood's new Puerto Rican immigrants, worked there for decades. The closure of many of the department stores that retailed the Quaker Lace products, however, proved too much for the company, which, after nearly a century in the hands of the Bromley family, declared bankruptcy in 1992. The firm's name and patterns were purchased by Lorraine Linens, which continued, with the help of a number of longtime Quaker Lace employees, to produce and market Quaker Lace tablecloths and curtains from its headquarters in Florida until its own bankruptcy in 2007. The vast Fourth Street plant, abandoned after the original bankruptcy, had been destroyed by a devastating eight-alarm fire on September 19, 1994, forcing hundreds of neighborhood residents from their homes and creating, for a brief period, a tent city of the displaced in the ruins. In 2003, the Julia de Burgos Middle School arose from the ashes and now stands as the neighborhood's new defining landmark.

LACE TRANSLATED

Even as Quaker Lace faltered and disappeared, the impetus that gave it birth survived: human fascination with delicate openwork textures that at once gently veil and tantalizingly reveal what lies beyond. That "series of threads around a hole" (as Quaker Lace once described its laces) opens a literal window into an entire range of universal concepts and polarities: positive and negative; soft and hard; feminine and masculine; organic and mechanical; light and dark; tradition and innovation. Through their interaction with Quaker Lace and Frederick Vessey in *Lace in Translation*, Tord Boontje, Cal Lane, and Demakersvan have entered into a timely and dynamic discourse around those themes, exploring, challenging, and overturning the expected and the predictable. In so doing, they ask us to confront our own assumptions — about lace, about design, about past and present, about inspiration and invention. We invite you to join us in that conversation.

1 Pat Earnshaw, *Lace Machines & Machine Laces* (London: B.T. Batsford, 1986), 9.

2 In fact, shortly after the Lace Fence was installed and students arrived on campus, a new student — intrigued by the fence — rang The Design Center's doorbell and asked to know more about the Center and its activities.

3 Martina Margetts, *Tord Boontje* (New York: Rizzoli, 2006),197.

4 *Concerning Window Draping* (New York: Quaker Lace Company, 1920), 4, trade catalog, Hagley Museum & Library, Wilmington, Delaware.

5 The following summary owes much to Pat Earnshaw, *Lace in Fashion* (Guildford, England: Gorse Publications, 1985) and Santina M. Levey, *Lace: A History* (Leeds, England: W. S. Maney & Son, in association with the Victoria & Albert Museum, 1983).

6 Carmen A. Weber, Irving Kosmin, and Muriel Kirkpatrick, "Quaker Lace Company — 1894," in *Workshop of the World* (Wallingford, PA: Oliver Evans Press, 1990), 5–25; Philip Scranton, "Build a Firm, Start Another: The Bromleys and Family Firm Entrepreneurship in the Philadelphia Region," in Geoffrey Jones and Mary B. Rose, eds., *Family Capitalism* (London: Frank Cass, 1993), 123.

7 Earnshaw, *Lace Machines and Machine Laces*, 175.

8 *The Quaker Lace Book* (Philadelphia: The Quaker Lace Company, 1913), 31, collection of The Design Center at Philadelphia University.

9 Scranton, "Build a Firm, Start Another," 126–27.

10 *The Quaker Lace Book* (1913), 11; *The Quaker Lace Book for 1914* (Philadelphia: The Quaker Lace Company, 1914), 24, collection of The Design Center at Philadelphia University; *Quaker Curtains* (1933), Scrapbook, 1913–28, in Quaker Lace Company Records, 1897–1972, acc. 2050, Hagley Museum & Library; Dorothy Ethel Walsh, *Correct Curtains and How to Select Them* (Philadelphia: Quaker Lace Company, 1926), 3, collection of The Design Center at Philadelphia University.

11 *Window Decoration* (New York: Quaker Lace Company, 1941), unpaginated, trade catalog, Hagley Museum & Library; *Twelve New Ideas for Decoration That Can Be Made at Home with Quaker Craft Lace* (New York: Quaker Lace Company, ca. 1920), unpaginated, trade catalog, Hagley Museum & Library.

12 J. Walter Thompson Co. Study, Sales Analysis (c. 1930), and pay rates, Quaker Lace Company Records, Hagley Museum & Library.

13 Scrapbooks, Quaker Lace Company Records, and Pictorial Collections, Hagley Museum & Library.

14 Philip Scranton, *The Philadelphia System of Textile Manufacture 1884–1984* (Philadelphia: Philadelphia College of Textiles & Science, 1984): 54; Video interview with Richard Fees, Director of Design, October 1992, Quaker Lace Company material, 1992.246, Hagley Museum & Library.

Lace Formation

MATILDA MCQUAID, *Deputy Curatorial Director; Head, Department of Textiles*
Cooper-Hewitt, National Design Museum, Smithsonian Institution

Facing page: Knotted Chair, Marcel Wanders. Carbon and epoxy-coated aramid fibers. Manufactured by Marcel Wanders, 1995. The Museum of Modern Art, New York, NY, U.S.A., Gift of the Peter Norton Family Foundation.

In the beginning there was needle lace and bobbin lace. Now after more than five centuries of lace history, techniques and materials have dramatically changed to encompass a more complex understanding of lace-making. Just in the last twenty years, lace has ventured well beyond the world of collars and trimmings to become a popular reference and inspiration in contemporary art and design.

Lace has meant something different to every century, and those looking back on its history see things differently through the lenses of their own times. Lace was at a peak of popularity in the nineteenth century, but through much of the twentieth century, many saw it as an unwanted heirloom and a reminder of suffocating Victoriana and what were seen to be that era's staid and priggish mores. Now, however, lace is proving itself to be as fascinating for twenty-first century artists and designers as it was in the nineteenth century. They use its form more literally than ever before, with creative interpretations coming to play through the use of unlikely materials and applications, as seen in *Lace in Translation*. Like many of their contemporaries inspired by lace, Demakersvan, Boontje, and Lane have deliberately made their work recognizably lacelike rather than disguising or forfeiting lace's distinguishing attributes in the name of art.

But what is considered lace, and how have its traditions been both retained and reinterpreted? Defining lace is difficult — its meaning has evolved over time and place, but in the most general sense, lace is a type of open work in cloth. More specifically, as defined by Santina Levey in *Lace: A History*, it is a "non-woven fabric constructed by the manipulation of either a single needle and thread or a variable number of threads wound on bobbins."[1] These definitions, however, are either too exclusive — the latter overlooks certain types of needle-lace and net-based fabrics that are considered lace; or too inclusive — the former counting some nonwoven fabrics that traditionally were not associated with lace such as cutwork, crocheting, knotting, and knitting. In the

end, however, they are all part of the present-day lace discussion, especially as it pertains to contemporary art and design.

Historically, bobbin lace first emerged in the late fifteenth and early sixteenth centuries, and evolved from braiding, most likely in Italy, which was a center for both passementerie (braided trim) and for silk and metal threads, of which early bobbin lace was made. When linen thread began to be used for insertions into and trimmings on clothing and household linens, the technique began to be associated with needle lace.

What is consistent throughout history and what continues to make lace so popular, however, is not a technique but a shared aesthetic, which conveys degrees of contrast, between a solid and void, for example, or hard and soft materials. Lace-makers primarily came out of embroidery workshops and created empty spaces around solid ones (which were also empty at one point). Through their extraordinary needlework skills they were able to represent qualities of transparency, opacity, and translucency in the cloth. These remain apt descriptors for work by the current generation of artists and designers who choose to work with lace as inspiration or, more directly, as an object.

For almost twenty-five years, the International Lace Biennial in Brussels, historically a center of lacemaking, was one of the best indicators of the creative directions of lace. The biennial featured themes such as transparency, lace in the third millennium, faith, and, at the final one in 2006, contemporary art. For this last-named theme, the objective was to encourage and promote the artistic development of contemporary art lace, and to search for new shapes, materials and/or techniques that demonstrate current ideas. Although the biennials' themes varied, the list of criteria for entry were fairly consistent: the work was to be made of interlaced, plaited, or braided fibers and threads; express novel forms, freedom of movement, fluidity, and transparency; embrace modernity; be similar to lace; and have poetry. This generous

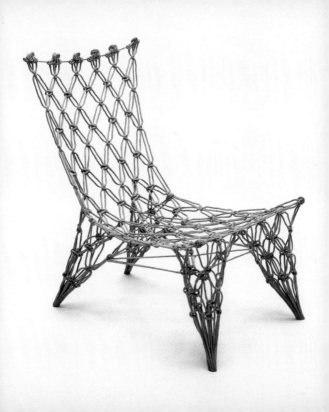

latitude for the artists most likely reflected the desire to be relevant and contemporary while subscribing to a more over-arching definition of lace as any type of open work in cloth. This inclusiveness, however, played a part in the Biennial's demise as it ultimately lacked focus and rigor. With some exceptions, lace became an artistic excuse for the work rather than a direct inspiration. In fact, by 2000 there was little work even remotely connected to lacemaking, and the loss of any seemingly visual connection to lace probably led to its downfall in that context. At the same time, however, lace became inspiration for many artists and designers external to the field of fiber and textiles, and it achieved popularity once again.

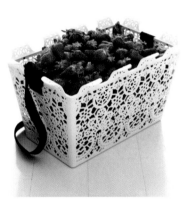

Some of them have explored lace as a functional and decorative object, making a stark distinction between historic and contemporary lace. The Dutch designer Marcel Wanders, formerly of Droog, has frequently explored different ways of intertwining fiber beginning with his iconic Knotted Chair (1996). Made from hand-knotted aramid and carbon fiber cord that is impregnated with epoxy resin and then draped over a mold, the chair seems to defy gravity as it magically stays rigid with or without an occupant. Wanders continued to experiment with this method in the cotton and epoxy Crochet Table (2001) and Chair (2006) constructed from individual, hand-crocheted flowers that are stitched together, placed over a mold, and stiffened with resin. Where originally decoration would have been the only purpose of a hand-crocheted fabric, Wanders gives it functional responsibility. The chair and table are perfect examples of reinterpreting both the function and technique of hand-crochet, now considered part of the lace family. One can even draw comparisons between the voluminous quality of Wanders' furniture and the spectacular standing lace collars integral to a gentleman's dress during the seventeenth century. Ethereal and enveloping, they each transform the user and the user transforms them.

Above: Carrie Bicycle Basket, Marie-Louise Gustafsson, plastic, metal hooks, polyester strap, 2007, Courtesy of DesignHouseStockholm.

Right: Metal-Lace Drain, Joana Meroz, stainless steel, 2006, Courtesy of Joana Meroz.

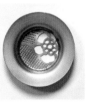

Numerous designers have also gone beyond the idea of lace as decorative accessory to create joyous utilitarian objects. For example, Joana Ozorio de Almeida Meroz from Brazil and Marie-Louise Gustafsson from Sweden chose lace as a way to apply pattern to something as banal as a sink drain and bicycle basket, respectively. Dutch designer, Tord Boontje, included in *Lace in Translation*, brings his lacelike Midsummer Light (2004) back to its textile roots, draping laser-cut Tyvek over a lightbulb to create a soft, pliable shade.

For centuries artists have been fascinated with contrasting textures and materials, and it has often been as much about the challenge of representing something soft with something hard as it is about realistically depicting the subject. For example, expressing the softness of silk or the human body in marble or wood is a technical feat and a way to show an artist's sculpting virtuosity. Grinling Gibbons, one of the foremost woodcarvers in the seventeenth century, who worked for English royalty as well as the renowned architect Sir Christopher Wren, often chose lace as a subject. In one of his most extraordinary carvings he captured the intricate details of a man's cravat, detached from human form, but carved as it would have been ultimately worn. Similarly impressive is an installation made four hundred years later, in 2001, by the French artist Elisabeth Ballet, who created a massive lace work with stone pavers in a square in Pont Audemer, France. Ballet transformed lace into a gargantuan "floor graphic." The overt contrast between the hard stone and supple textile inspiration, as well as the intimate scale of lace versus the monumentality of a public plaza helped to create a brilliant urban experience that is emotionally and architecturally transformative.

For some artists and designers, technique will always be the main inspiration for their work, and lace is no exception. These individuals may have retained some of the traditional lace-making techniques, but they have chosen new parameters in which to work. One of the most talented makers of contemporary lace is Thessy Schoenholzer Nichols, who describes her point of departure as:

> the study of the old techniques, especially the forgotten ones, of bobbin lace making. And hence it is the technique, the infinite possibility of expressing oneself by intertwining the threads that fascinates me and enables me to realize my work. My intense involvement with the history of lace determines my choice: the use of very fine thread such as was made once-upon-a-time and the creation of restrained works. My laces are seldom completed or enclosed in a picture frame, but they always remain unfinished pieces, like fragments, which leave the way open for many interpretations and points of view.[2]

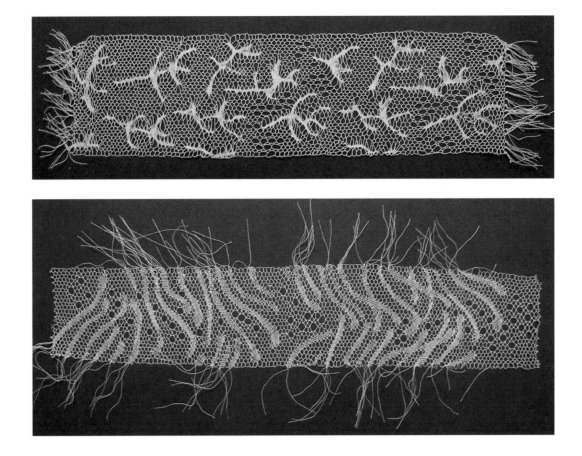

Nichols' work is what all of the Lace Biennial participants should have aspired to — its adherence to specific lace-making techniques with a contemporary sensibility that would never be confused with an earlier time. Her work exists as a solitary unit detached from garments and other textiles that would have made it complete in previous centuries. It is neither embellishment nor utilitarian, but perfectly bridges the gap between past and present, lacemaker and artist.

In the end, it is this constant reinterpretation that keeps lace and its history alive. At a minimum these explorations force a dialogue between past and present, but ideally they also open up communication between disciplines, introduce the unfamiliar or unknown, and ultimately inspire artists to seek new sources and directions. Undoubtedly an understanding of technique only helps to enrich an artist's or designer's foundation and ability to translate more accurately and poetically lace or the idea of lace into other media, and thus makes the work truer to its source of inspiration. As this kind of knowledge determined the extraordinary artistry of the lace-maker centuries before, it continues to have relevance today.

[1] Santina Levey, *Lace: A History* (London: Victoria & Albert Museum; W.S. Maney & Son, 1983), 1. Levy gives a very informative explanation about early bobbin and needle laces, which can be summarized to help in understanding how lace has evolved after the first appearance of bobbin lace and also indicate how loosely it is currently interpreted.

At the very earliest, needle lace depended upon a woven ground because it evolved out of white embroidery and cutwork, although pure needle lace has no woven foundation. Instead, needle lace is built up of rows of detached buttonhole stitches on an outline structure of thick threads that have been tacked along a design drawn on a parchment pattern.

Similarly, bobbin lace is built on top of a parchment pattern pinned to the curved surface of a hard pillow, but the design, rather than being drawn, is marked by a series of pricked holes. The holes serve not only to trace the lines of the design but also to mark the stitches made by the lace-maker, as she manipulates pairs of threads wound around bobbins. As the work progresses, pins are placed through the pricked holes to hold the finished stitches and surrounding threads taut and in the right place while the next stitch is made.

[2] Cieta Lace Group-Newsletter no. 27 (1998), unpaginated. In the Textile Department of the Cooper-Hewitt, National Design Museum.

WHILE YOU CAN CONSIDER IT AN ART PIECE, IT'S A FUNCTIONAL PRODUCT.
IT COMPETES WITH INDUSTRIAL PRODUCTS. AND IT'S GROWING.

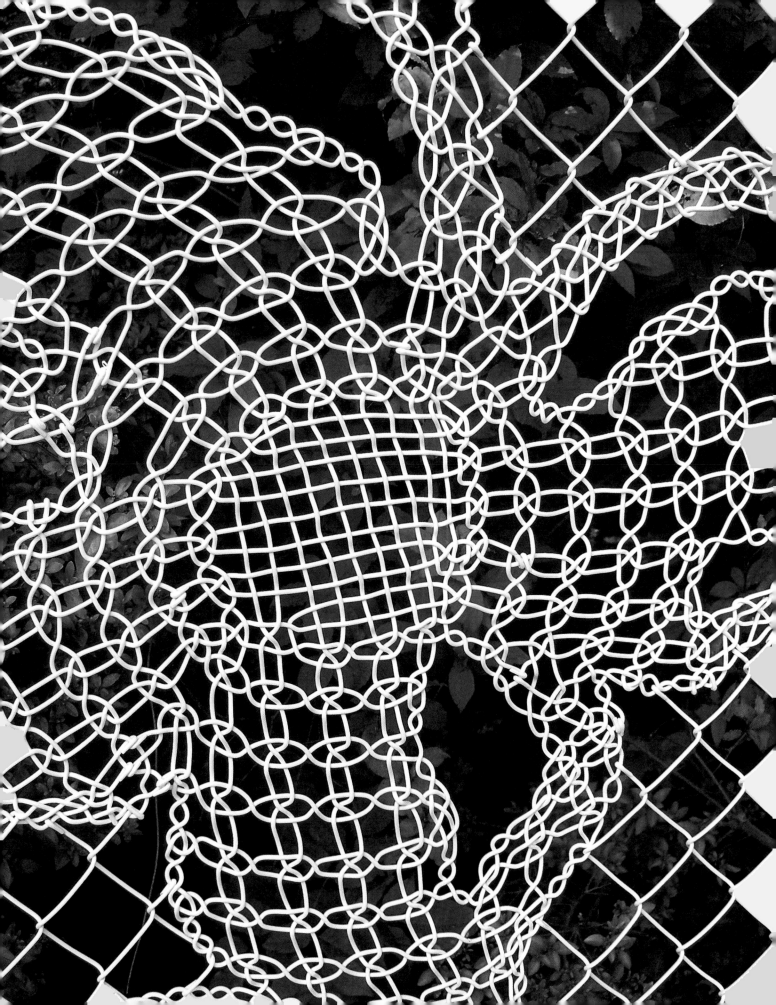

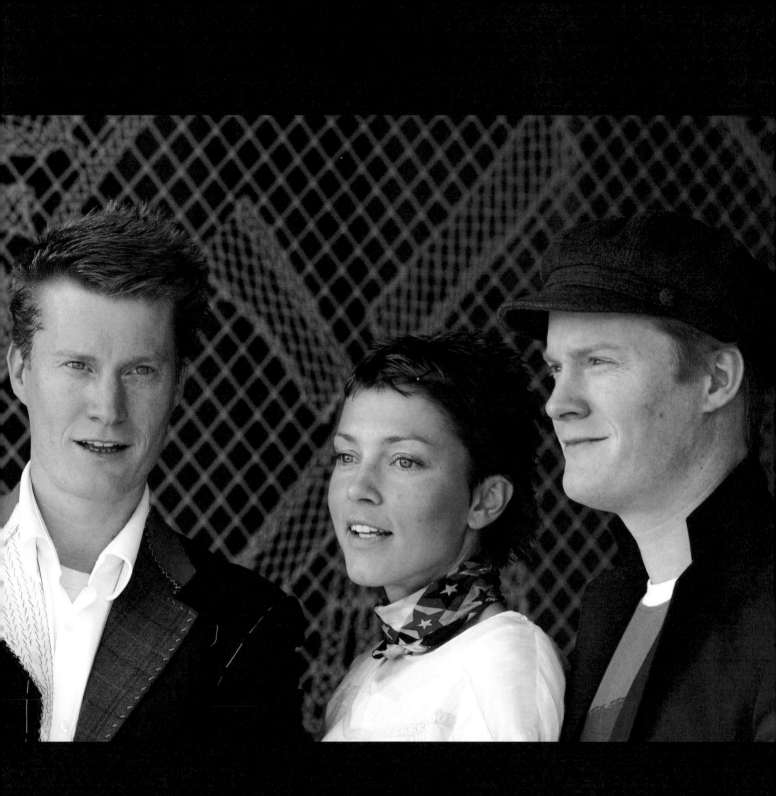

The Demakersvan design team:
Joep Verhoeven, Judith De Graauw,
and Jeroen Verhoeven. Courtesy
of Demakersvan.

DEMAKERSVAN

From an Interview with Joep Verhoeven

Demakersvan is a Dutch design studio. The name, translated, means "The makers of..." That is the beginning of a phrase, and that's also our philosophy, in a sense that we are storytellers. And we always start with "The makers of...." Then we keep it open, so we don't box ourselves in. We don't design only interiors, or exteriors — there's a mix, and we mostly do products. And while there may be a lead designer, we always collaborate together as members of the studio.

We are most interested in products that are not only for our clients or ourselves, but those which are found all over the world and almost in the same form and identity. A fence is a really clear example of that. It's a necessity in society; fences mark who we are as human beings and as a species. Very early in the evolution of society we needed fences or barriers. Once people started to grow food and cultivate land, there were fences to protect it and to mark what was theirs and not a neighbor's. They're about boundaries, and in that sense, a fence is a really fascinating subject.

You see fencing all over the world, in both developed and developing countries, and especially chain link. Industrial chain-link fencing is everywhere, all the same color, all the same idea. And that always fascinated me, that it fills a need and it is transparent. People don't really appreciate it, but it actually has a high value if you stop to think about it. So I wanted to look into the possibility of bringing this into balance, to harmonize and make appreciation equal to its value. We have worked with it as a product, combining the industrial with our ideas, with the concept of craft.

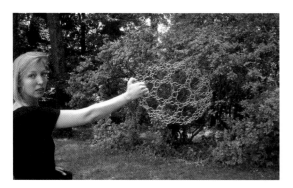

Above: Demakersvan team member evaluating potential locations for Lace Fence installation at The Design Center during their site visit in 2007.

Facing page: Installation of Lace Fence at The Design Center, August 2009.

Page 35: Detail of Lace Fence for *Lace in Translation*, Demakersvan, 2009.

Page 37: Lace sample used by Demakersvan for inspiration (see page 11).

That's the idea behind Lace Fence. I designed different fences, different concepts, but rather than being really resolved, they were more statements than something that could actually be used. At first it was a statement, and then it arrived in museums. And from museums it went to galleries, and then from galleries to a factory, or really a studio, for production. It grew, it branched out, but those first aspects are all still there. Museums still consider it an art piece. Architects consider it a product. In that sense, it really does connect with the philosophy of our studio. We like to take a broad view, and not focus on only one aspect but to be as multidimensional as possible; that is the more fashionable thing in my opinion. What I really like about Lace Fence is that while you can consider it an art piece, it's a functional product. It competes with industrial products. And it's growing.

At the outset, I underestimated Lace Fence's impact, and a lot of projects have come up with different applications — even for ceilings. And for balconies, of course, but also art pieces, like paintings, like wallpaper. Now people are starting to be imaginative, and are thinking of applications that I never would have thought of. That

is actually the point of the whole design, or the concept: to inspire, to trigger people's imagination.

Smaller scale projects are coming in from all over the world, from China, Russia, parts of Africa, but most of the really big projects are in our own country. Maybe it's because we're based in the Netherlands, and it requires a lot of communication and working closely with the client. The Design Center's is the very first Lace Fence in North America, the first permanent installation, not just a temporary exhibition, in the United States or Canada. So it's a very high value project, a nice start for Demakersvan.

THE BEGINNINGS OF LACE FENCE

The first Lace Fence was in 2003: I made a sample, just a scale model. And since I didn't know the technique, I went to a class taught by old ladies. This trade is mostly women, most a little bit elderly, and they taught me lace techniques, and of course there are a lot of techniques. I looked at how many kinds of fabric are made, I did extensive research in fabric techniques, and the only technique that is suitable for working with a thicker, more rigid wire — which is difficult to handle because of its limited ability to bend — is lace. With lace, you just put one wire over the other, as in a braid. Knitting, for example, would never be possible with wires as thick as those we use. We've managed to make an almost literal enlargement of lace, of what they made in the early days. In Dutch, the term for chain-link fence is *vleche hakwerk*, "braid fence." It's named with a fabric technique, and that's where my fantasy originated. It's a technique at the core of lace.

LACE

I was always intrigued by the fact that lace takes so much time and effort — you really felt that somebody worked on it. And you identify with that somehow. With lace, there's so much detail; as a viewer, the more you focus, the more layers and the more detail you will see. That is fascinating to me. Also, I think I appreciate its high quality, how it's produced, and the dimensionality in a two-dimensional surface, how it has so many layers but is mostly 2D, which is really fascinating.

[For *Lace in Translation*] it was really fascinating to have such an extensive collection to choose from for a model, not just Belgian lace, say. I selected a piece that had clear shapes, honest shapes, that isn't too much like rococo or what you'd see in French lace, with a lot of decoration. Rather than trying to make a strong impression, it has a charming and innocent quality — I see it as a young girl, and not like some posh lady;

it's more an innocent girl. It's really honest. If you see it as a person, it would be a really kind one. It was a choice based on emotional qualities. I really like it.

I didn't see lace at all while growing up, and then I went to the only lace factory that was still running in Europe, which has long since gone bankrupt, for they could not make machines that could produce large pieces of lace. Even for a small one, just a few inches wide, you need a huge machine. There are some machines that can make lace faster than handwork, but it's industrial, and you immediately feel that it lacks something.

DESIGN AND PRODUCTION

We combine an industrial product with the handmade. We start with just spools of wire of varying thickness, so we have different qualities of wire. I began just sketching by hand, but now I design patterns on the computer, and then I send the designs to the fabrication studio, where there are no machines, only people who work with their hands. A lot of people think that because it's so perfectly made it's made by machine. At the beginning I did investigate developing a machine for this, but the cost to develop one that could make the complex patterns with such rigid wire was enormous. And now the workers at the studio in India are so experienced that I can just give them a sketch and the dimensions, and they know what to do. It takes one person two days to make one square meter, or about ten square feet.

Indian culture is well known for craft, or handmade designs, and it is known all over the world for fabrics, but the people that we needed were not textile makers with needles but workers with wire and hammers. So we went to construction sites, and we chose bar-benders, men who work with the rebar for reinforced concrete. Actually, it's really a nice contrast, these tough guys making this nice, somewhat cute fabric.

One visitor to our factory said he had never seen such motivated people: they realize they are making something really special. It makes them proud.

And now they're starting to understand the graphic qualities, and if lines are not correct, one will suggest another way to do it, and sometimes he's right — a construction worker who never had an opportunity to think like that. One visitor to our factory said he had never seen such motivated people: they realize they are making something really special. It makes them proud.

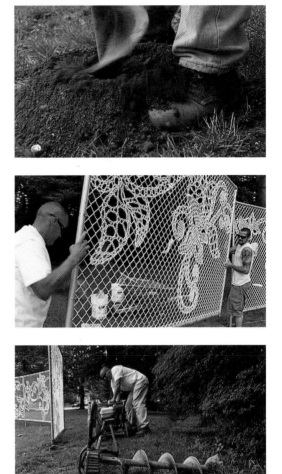

LACE FENCE EFFECTS

People today are really busy, not only with work but also in everyday life — even when they're just relaxing, they want to do a lot. Sometimes you miss the beauty of everyday things and everyday life, in what surrounds you. This fence is really like an eye-opener. I hope people will stop and realize: I've seen fencing like this all my life, but I never thought about it in this way. And then maybe when they see some other things around them, like a dustbin, they will think maybe this isn't just a boring object, but it can be beautiful. This is really big for me — inspiring people. To get them to look beyond the end of their nose. There is more fantasy and more opportunity, more freedom in our surroundings than you think, or than most people expect. So that's one motive — surprising people.

INDUSTRIAL CHAIN-LINK FENCING IS
EVERYWHERE, ALL THE SAME COLOR,
ALL THE SAME IDEA. AND THAT ALWAYS
FASCINATED ME, THAT IT FILLS A NEED
AND THAT IT IS TRANSPARENT.

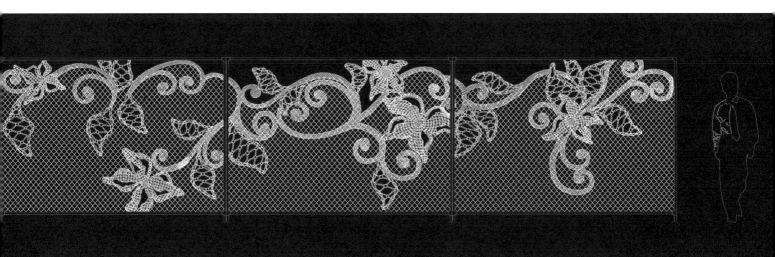

This page: Details of original proposal
for Lace Fence for *Lace in Translation*,
Demakersvan, 2008.

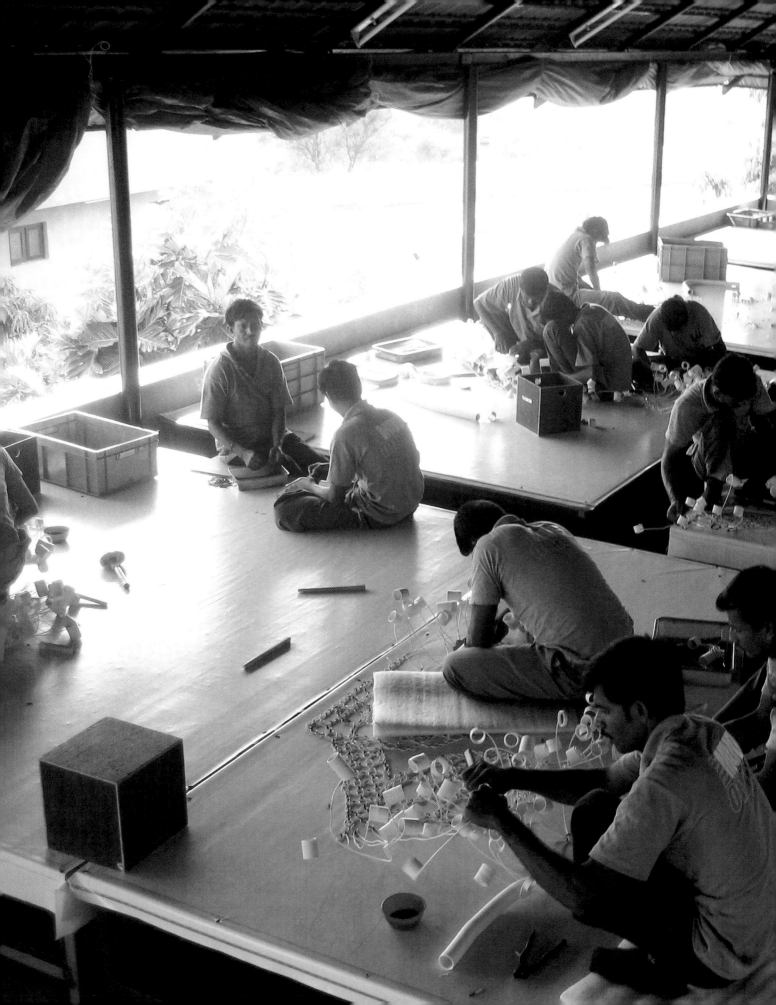

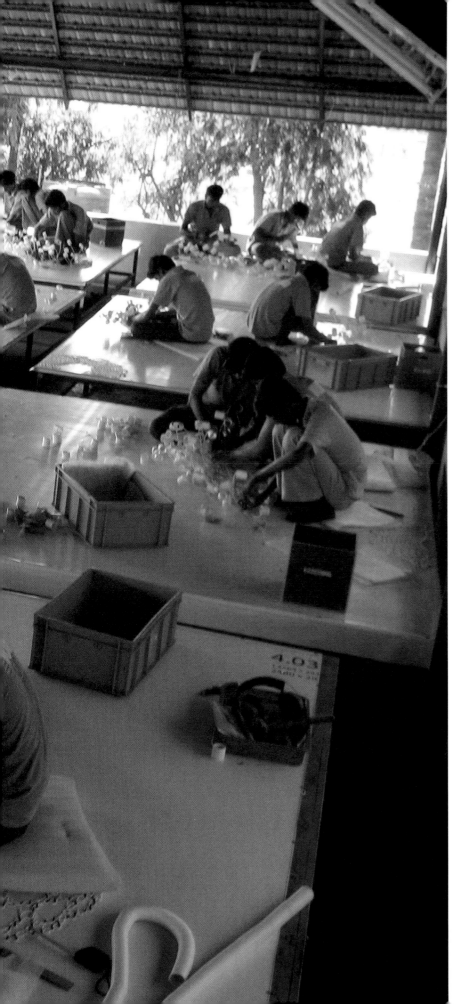

THE PEOPLE THAT
WE NEEDED WERE NOT
TEXTILE MAKERS
WITH NEEDLES BUT
WORKERS WITH WIRE
AND HAMMERS...
IT'S REALLY A NICE
CONTRAST, THESE
TOUGH GUYS MAKING
THIS NICE, SOMEWHAT
CUTE FABRIC.

Lace Fence production studio,
Bangalore, India, 2008.
Courtesy of Demakersvan.

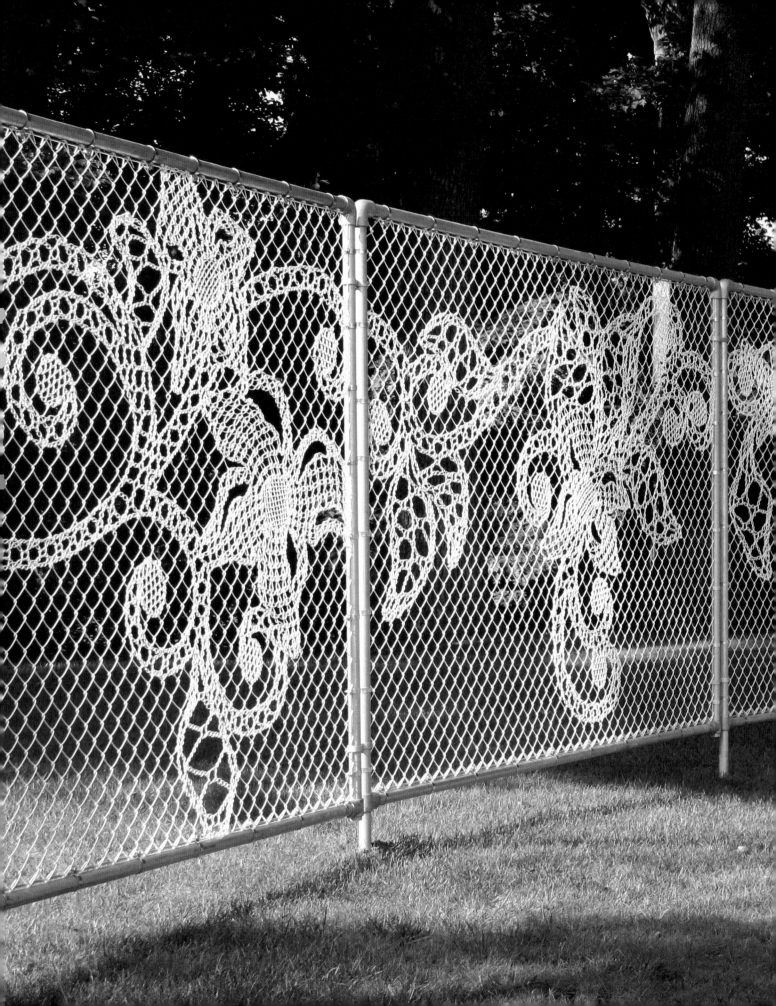

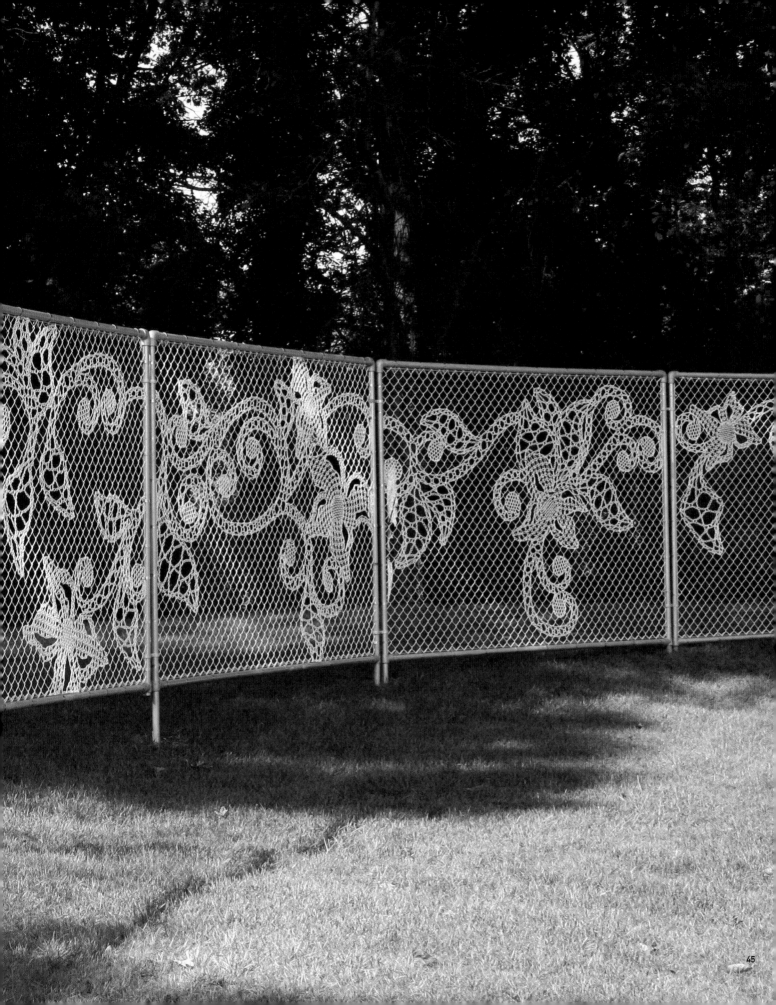

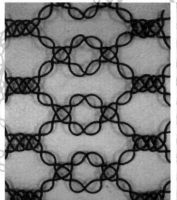
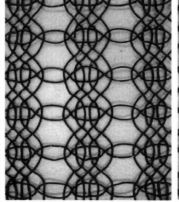
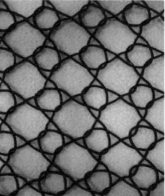
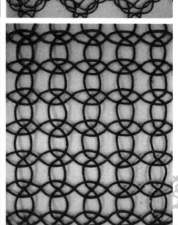
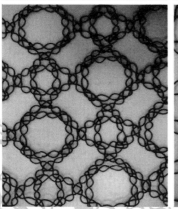
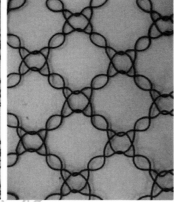
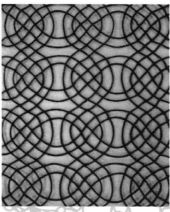

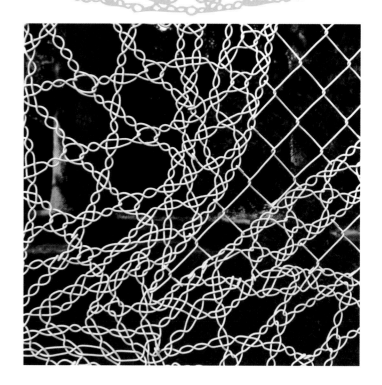

Above: Variety of wire lace stitches
used to create Lace Fence.
Courtesy of Demakersvan.

Right and background: Details
of The Design Center's Lace Fence.

Pages 44 & 45: Completed Lace
Fence installation at The Design Center,
Philadelphia University, 2009.

Pages 48 & 49: Lace Fence as
installed, Philadelphia, 2009.

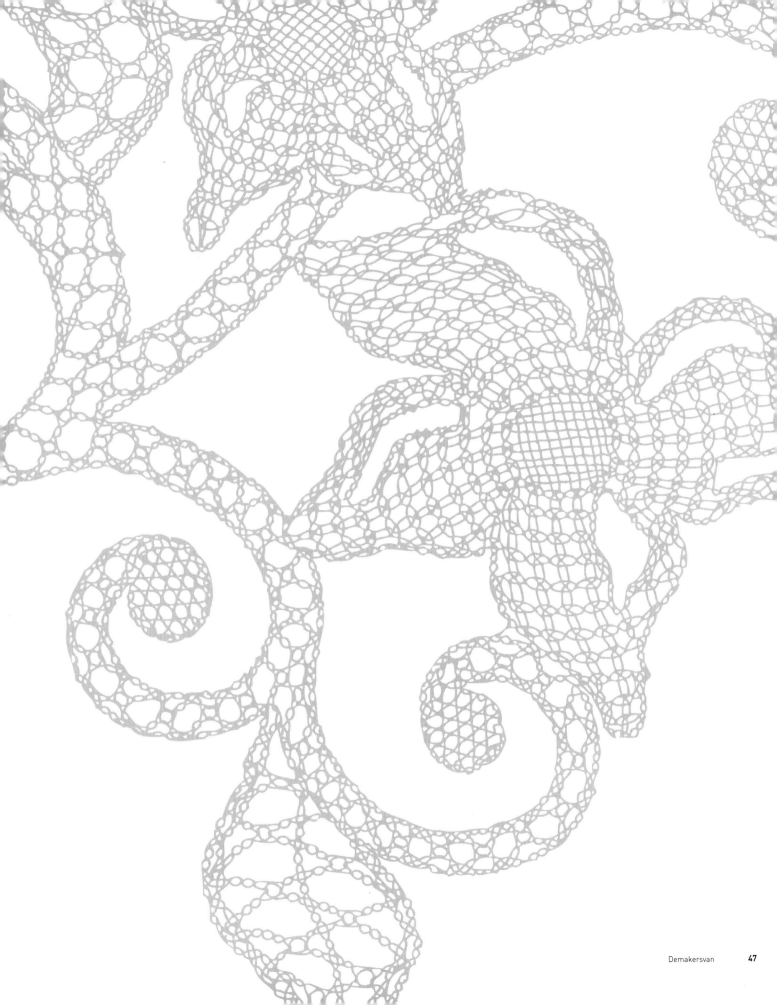

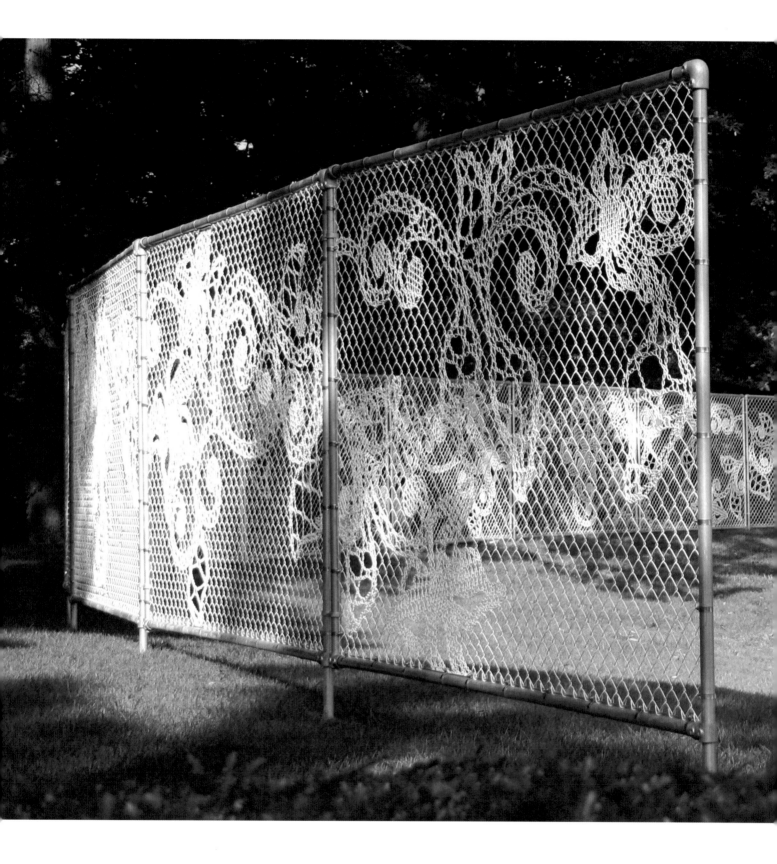

I HOPE PEOPLE WILL STOP AND REALIZE, HEY, I'VE SEEN FENCING LIKE THIS ALL MY LIFE, BUT I NEVER THOUGHT ABOUT IT IN THIS WAY.

A GIRL FROM THE COUNTRY IS GOING TO A PARTY AND HAS NOTHING
TO WEAR BUT SHE HAS GOT SOME STRAW, A HOLLYWOOD MAGAZINE,
AND AN ABILITY TO MAKE THINGS BY HAND.

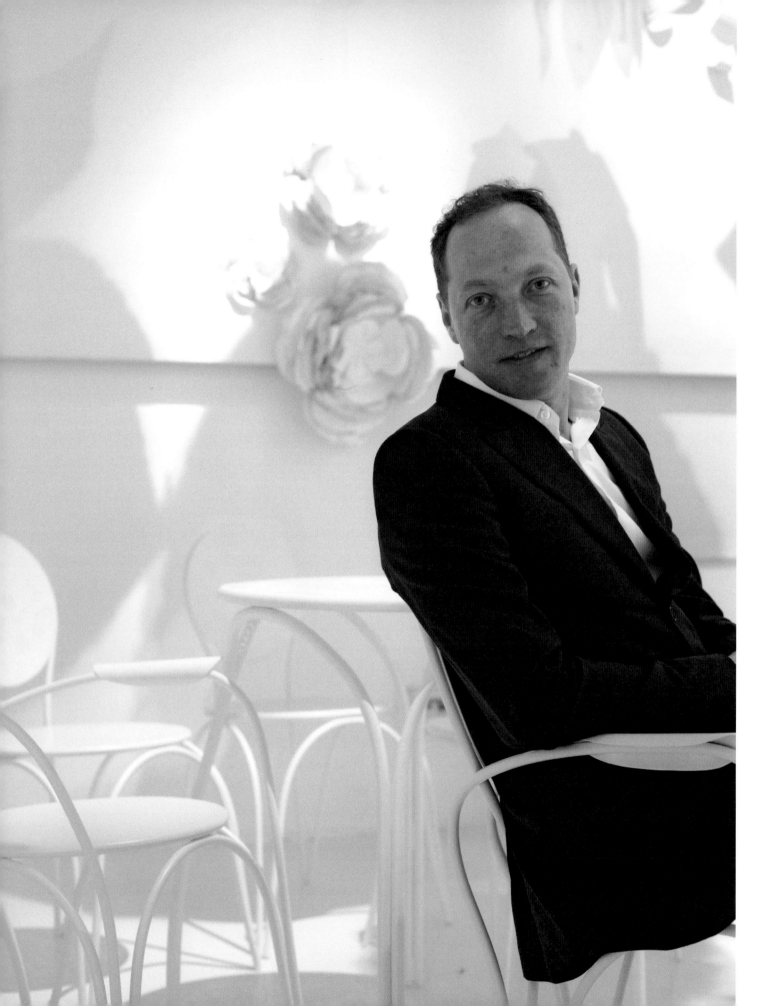

TORD BOONTJE

I am constantly inspired by culture and nature, books, and music as well as art. A recent trip to Africa opened another world of animal life, but where I live, right out my back door, is full of wonder. For instance, after the snows finally melted, I saw a bright green lizard basking in the sun. I am an avid reader and listen to music every day. I am also passionately concerned about what is happening in the world because of climate change, ecology, and social injustices. I constantly read a mix of news, literature, and fantasy.

In my designs, I don't normally set out to tell specific stories. I look at relevant issues around a project and stories form themselves. Table Stories (2005), a ceramic collection, was intended to allow the mind to drift very much as one's childhood imagination does. Many people recall a pattern on china and remember the significant feeling it triggered, part of a tradition of narrative pieces, but maybe very personal, taking place inside your own mind. If you steep yourself in visual art and inspiring places and information, if you think and ponder, this will all emerge in a work. Take the Fig-Leaf Wardrobe. I decided on the fig leaf because of the connection to the original clothes, but was not prepared for the bigger story that people's vision revealed — a secondary level of meaning.

I am working on a large architectural commission to design graphics for the windows of a new wing for

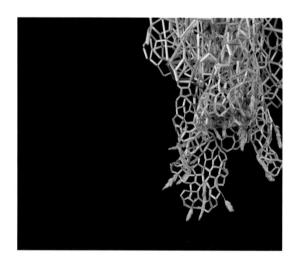

Great Ormond Street Children's Hospital in London. Its jungle of plants and animals will inevitably tell a story, but we chose the design for many reasons — some to do with the building's scale and location in a historical neighborhood, others with bringing something familiar and comforting to children from all over the world who stay at the hospital.

Right now I am looking at the idea of memories to inspire mosaic patterns. To find or develop images that trigger shared memories. Images of landscape rushing by as we move by car, continually changing, narrative, filmic. There is a pattern of a water surface. When I look, I become lost in the sparkles and ripples; maybe my imagination goes through the surface and another dream begins.

Above: Detail of grass light for *Lace in Translation*, Studio Tord Boontje, 2008.

Facing page: Experimental grass lace sample, Studio Tord Boontje, 2008.

Page 53: Vignette of girl wearing raffia lace dress created by Studio Tord Boontje, Bourg Argental, France, 2008. Courtesy of Studio Tord Boontje.

Page 54: Designer Tord Boontje. Courtesy of Studio Tord Boontje.

Page 55: Detail of machine-made lace by Westchester Lace used in *Lace in Translation* gallery installation. Lace courtesy of Westchester Lace and Textiles, Inc., North Bergen, NJ.

MATERIALS AND MACHINES

Materials are incredibly important to me. Every material has a different resonance and it also has something to say about the times we live in, what people are concerned with right now, and what my instincts are about this or that. Having a relevant feeling about these things is part of my job; I put new things into culture regularly and feel part of a collective cultural movement. I have strong beliefs about the ethical use of materials and had no problem recently turning down a project with a large technology company because their proposed material was polyvinyl chloride or PVC, a poisonous plastic. The value and status of a material have always fascinated me, like finding beauty in a cardboard box as well as in gold — both are humbling to work with. I always want to look at the latest developments with materials, and, if appropriate, experiment or try something new. I am also just now working with a company to develop a new material where we press flowers on wooden boards, like you might dry them inside a book. This new material then becomes the starting point for a new furniture collection.

We live in exciting times. Both craftsmanship and machine production seem so incredibly relevant. We are human. We sometimes want to work with our hands if we can. It keeps us sane and I would feel a bit useless if I was completely unable to make things around me...I love doing that. At the same time I am a product designer and have always visualized myself working in industry, visiting automated factories. New technology is a passion. I see myself as extremely lucky, having achieved a balance between the two. This is informed by a political stance as well: we live in a time when technology might help in the survival of humankind or might be a destructive factor. It is also a time in which the developed world should not forget about the alternative to a technological society — walking instead of driving, making things by hand yourself, growing your own vegetables.

LACE AND LACE IN TRANSLATION

I've not formally worked with an historical collection before, but the textile collections at the Victoria & Albert Museum had a big impact on me as a student, and after college I spent a lot of time in the museum. For *Lace in Translation*, I like that there is a local past in the Quaker Lace Company collection at The Design Center, a tradition of lace-making and the romantic memory of lace in fashion and interior use. We live constantly and intensely with the present, past, and future. If, as an artist or designer, you are not holding all three at once, if you don't keep yourself informed by all three, it would be hard to make great work.

My Swedish grandmother made bobbin lace, and I loved watching her doing this when I was a small child. My own lace vocabulary emerged through cutting away rather than building up. It came through direct translations of nature, looking up to the sky through the layers of sunlit foliage — these kinds of things remind me of lace. In the Wednesday Light (2002) and the Midsummer Light (2004), the laser-cutting and die-cutting processes are evocative of lace. As in the natural world, where foliage is spatial and formed in three dimensions, I started to look at a layered image and three-dimensional lacelike structures to invoke this intricacy that is so fascinating to me. Lace is fine, delicate, lightweight, and can be exquisite, and I like that it holds and reflects light. I wanted to bring that to the installation.

I started using grass to make my first samples. I did not want to use any materials that would compare to a skilled tradition and convention.

For *Lace in Translation*, I started using grass to make my first samples. As this was a testing and thinking stage, I did not want to use any materials that would compare to a skilled tradition and convention. For the next samples and pieces, I started using raffia as a more durable material but still completely not precious. I remember macramé from the seventies, something hobbyists worked with. But when I visited Africa and saw villages completely built out of grass and palm fronds, I realized that what seem to us forgotten and unusual materials are for a large portion of the world's population completely ordinary, everyday materials. I feel somehow these materials are socially relevant now: materials that are organic, nonpolluting, free, sustainable, and beautiful to live with.

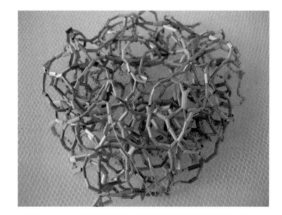

Lace is not really a motif for me but a structure. My previous work was very much about cut-out patterns, but for the development of the new work for this exhibition I started to think about construction rather than reduction as a method. We have had designers regularly attending weekly lace-making classes. These are young women who sit and work with the elderly population of the village — this is a great metaphor for bringing the past and the future together: it makes me happy to know this is happening. I see a whole new style of products; I know it will impact heavily on our future work, maybe a continuation of work started with crochet workers in Rio. The work for this exhibition has also prompted me to think about construction versus reduction, which I am sure will continue to be a factor in the studio's work.

The narrative of the work for this project has probably become more complex and abstracted than before, but my other work has been developing also in this way. In *Lace in Translation*, I imagine a story: a girl from the country is going to a party and has nothing to wear, but she has some straw, a Hollywood magazine, and an ability to make things by hand. The woman falls in love with a spider. This is the beginning of an impossible relationship.

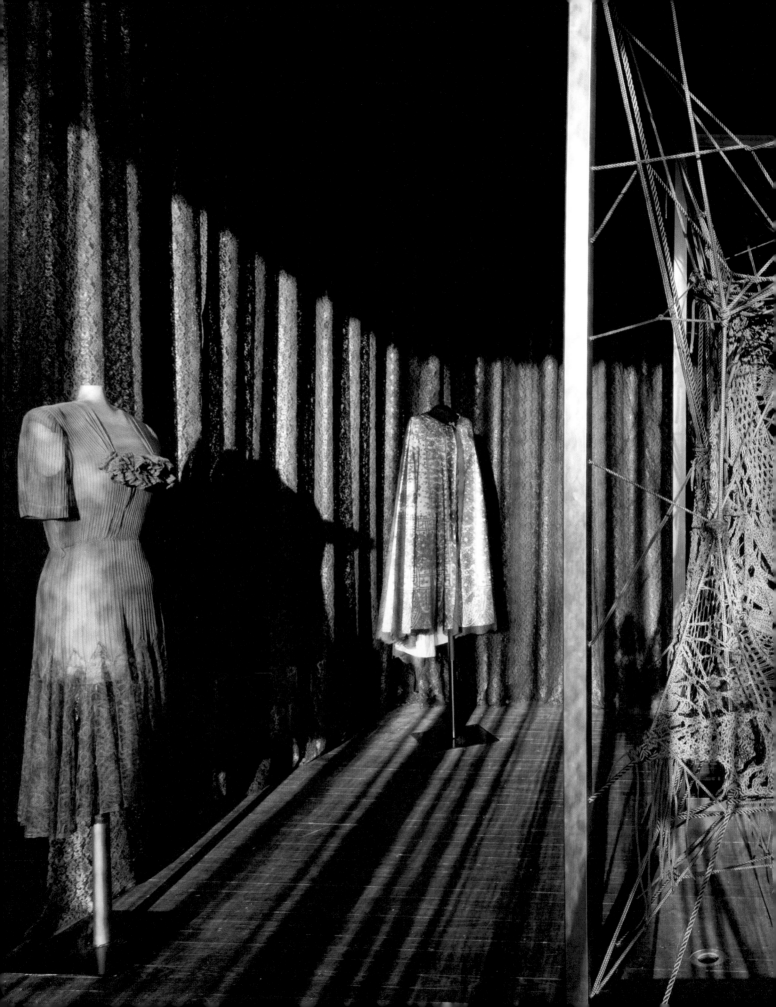

THE GIRL FALLS IN LOVE WITH A SPIDER.
THIS IS THE BEGINNING OF AN IMPOSSIBLE RELATIONSHIP.

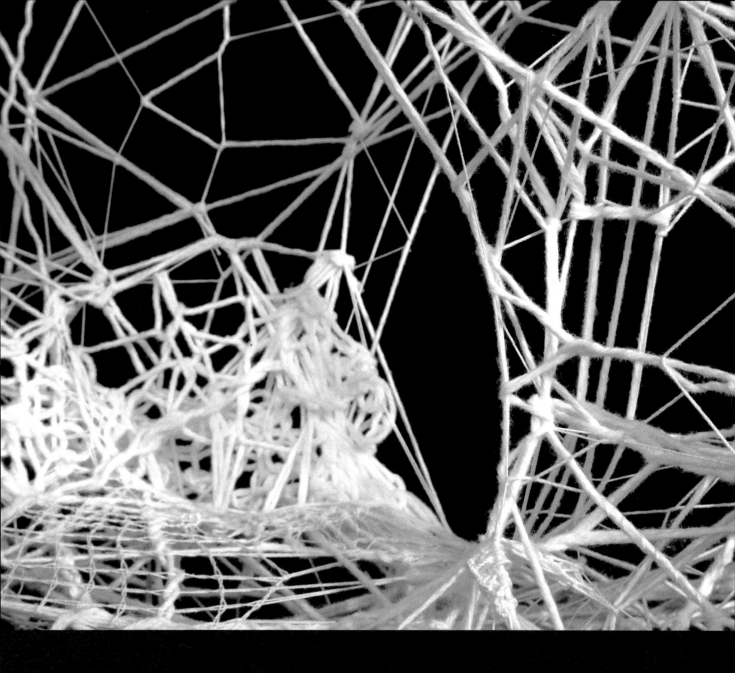

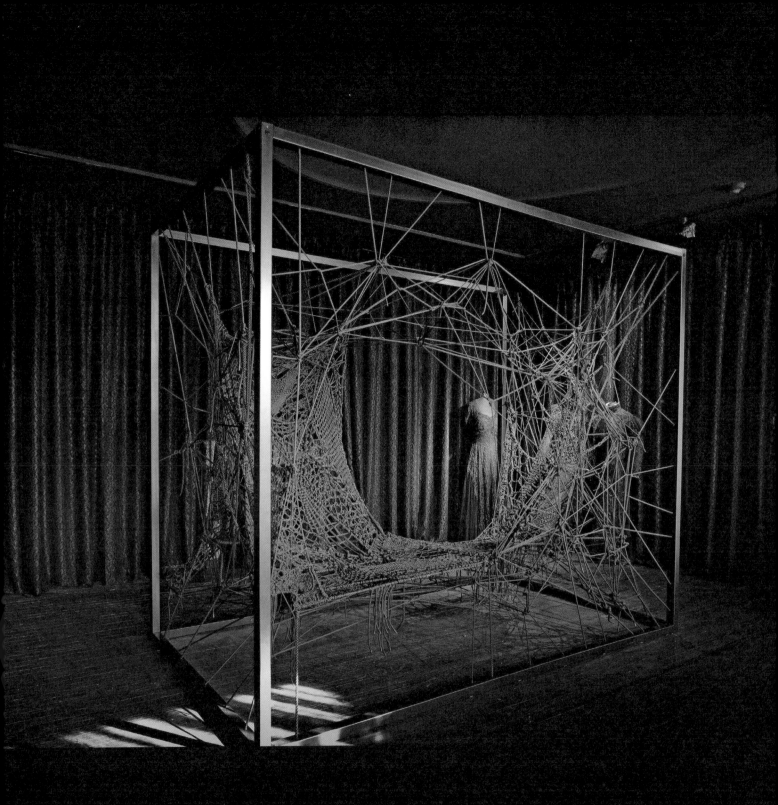

Above: Spiderweb-inspired sofa for *Lace in Translation*, Aramide and Dynema fibers on powder-coated steel frame, Studio Tord Boontje, 2009.

Facing page: Detail and overall view of sofa maquette, yarn and wood, Studio Tord Boontje, 2008. Courtesy of Studio Tord Boontje.

Pages 58 & 59: Tord Boontje's gallery installation for *Lace in Translation*, with spiderweb sofa, machine-made lace drapery, and historical lace garments from The Design Center's collection.

LACE IS NOT REALLY A MOTIF FOR ME, BUT A STRUCTURE.

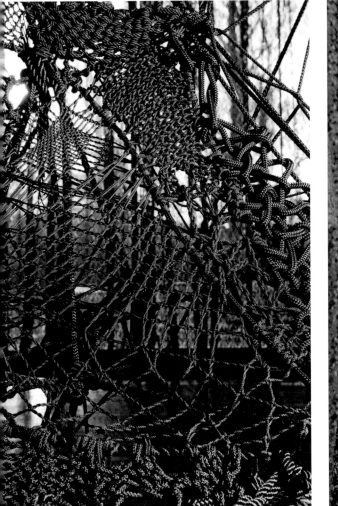

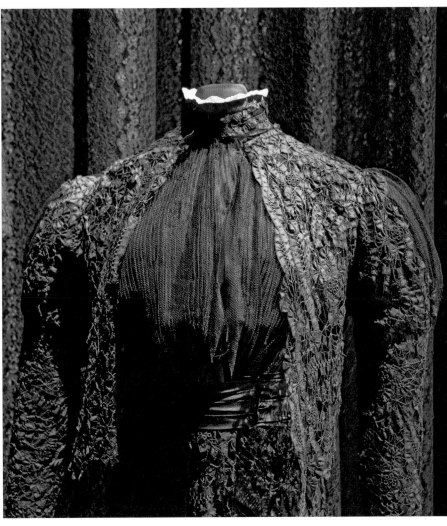

Above left: Detail of spiderweb sofa, Studio Tord Boontje, 2009.

Above right: Detail of lace dress; silk lace, thread, tulle, and crepe with silk velvet and cotton trim; probably America, ca. 1900. Collection of The Design Center at Philadelphia University.

Facing page: Detail of installation. On mannequin: Cape; cotton lace, synthetic grosgrain lining; Europe, 19th century with later lining. Collection of The Design Center at Philadelphia University, gift of Ms. Rita Beuchert.

RAFFIA...GRASS...PALM FRONDS —
ORGANIC, FREE, SUSTAINABLE, AND
BEAUTIFUL TO LIVE WITH.

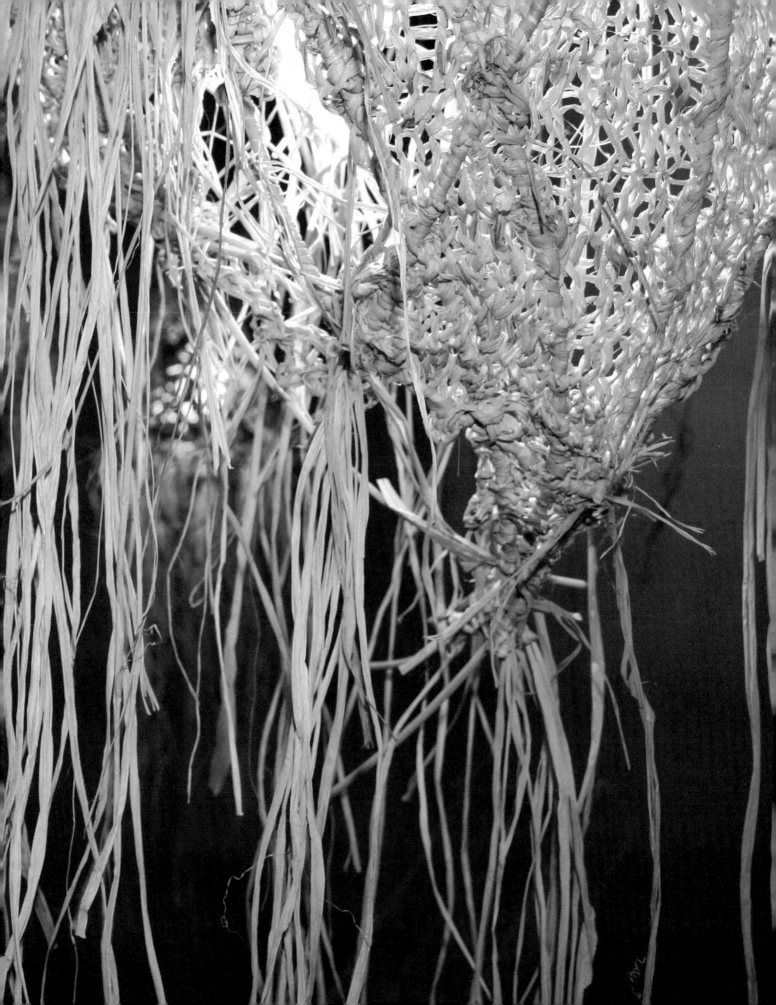

MY OWN LACE VOCABULARY CAME THROUGH
DIRECT TRANSLATIONS OF NATURE.

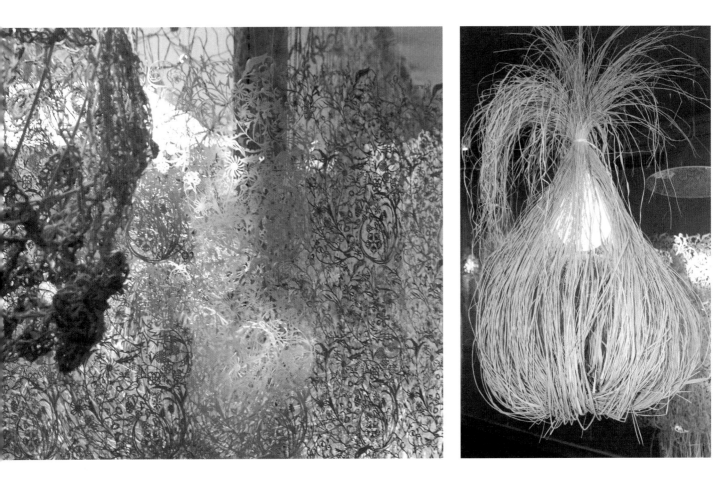

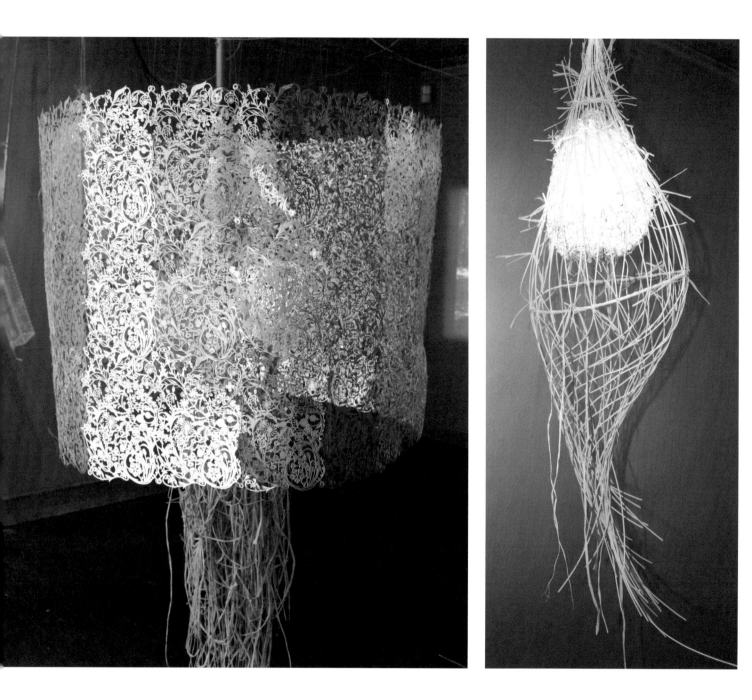

Above left: Tord Boontje's Ivy Panels for Artecnica, 2008, surround a raffia lace dress.

Above right: Wicker and raffia lighting fixture for *Lace in Translation*, Studio Tord Boontje, 2009.

Right and facing page: Details of raffia and wicker lighting fixtures, Studio Tord Boontje for *Lace in Translation*, 2009.

Pages 70 & 71: Detail of raffia lace curtain, hand made by a team of students, staff, and faculty at Philadelphia University, headed by *Lace in Translation* co-curator Carla Bednar with assistance from Professor Marcia Weiss, School of Textiles and Engineering.

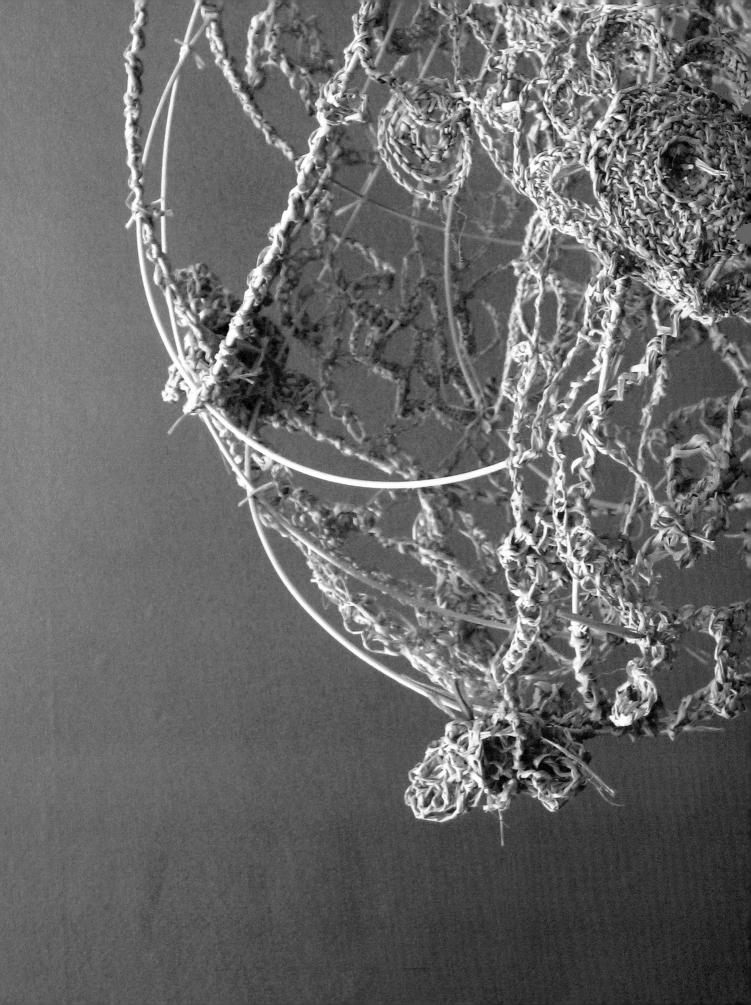

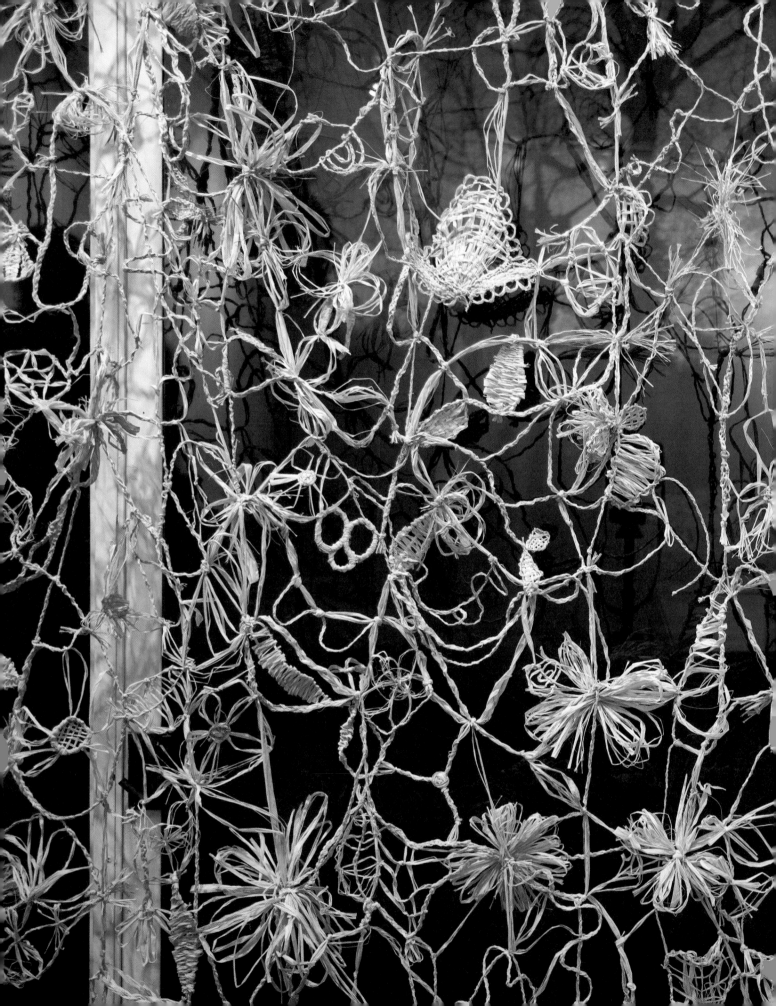

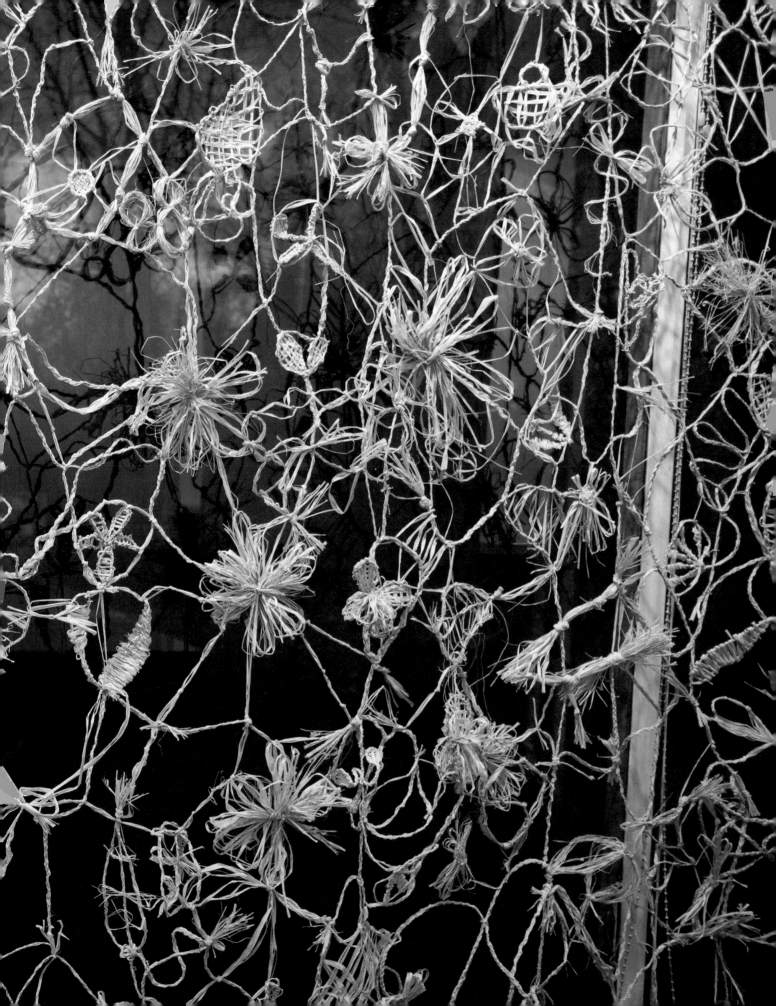

Above: Gallery view of case with grass, straw, and raffia lace samples, Studio Tord Boontje for *Lace in Translation*, 2009.

Right: Grass, straw, and raffia lace samples, Studio Tord Boontje, 2008.

Facing page: Detail of a spiderweb sofa maquette, yarn and wood, Studio Tord Boontje, 2008.

Pages 74 & 75: Gallery view featuring "100 Years," laser-cut Trevira CS fabric panels designed by Tord Boontje, manufactured by Kvadrat, Denmark, 2009.

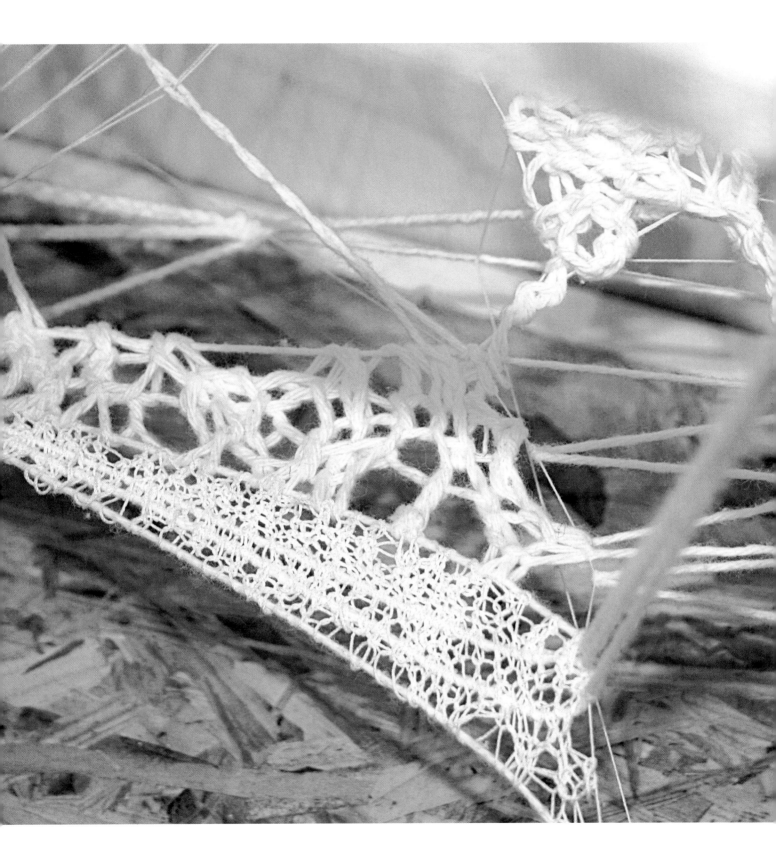

LOOKING UP TO
THE SKY THROUGH
THE LAYERS OF
SUNLIT FOLIAGE —
THESE KINDS OF
THINGS REMIND
ME OF LACE.

THE METAPHOR OF LACE...INTRODUCES A KIND OF HUMOR THROUGH THE FORM
OF UNEXPECTED RELATIONSHIPS, LIKE A WRESTLER IN A TUTU.

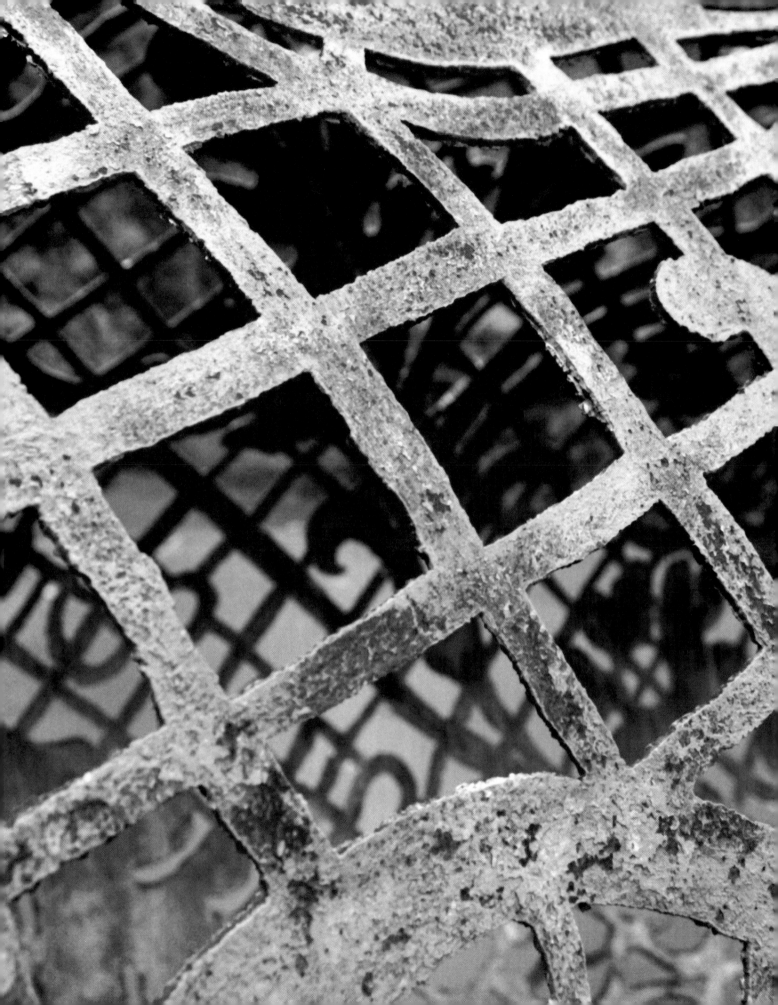

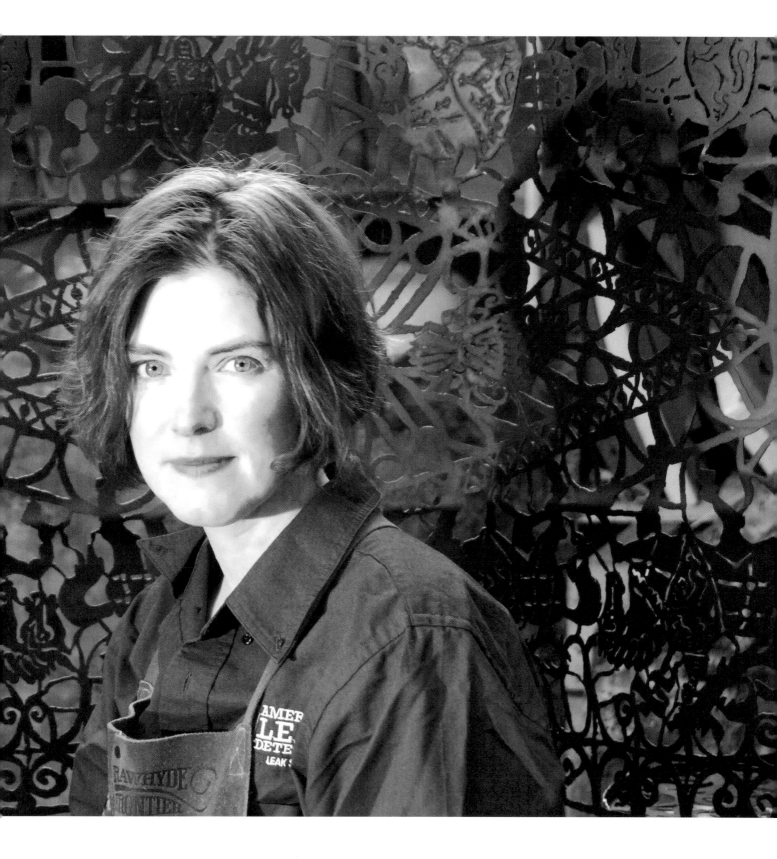

CAL LANE

The image of lace began as a way to illustrate the conflicts I was experiencing in life. The delicate white fabric became a metaphor for what society expected of me but what I refused to become. Life's training to become a nice, clean, sweet, pretty girl to be looked at, not free to experience life, only created an anger and desire to be tough, foul-mouthed, street-smart, and wise. Lace became a symbol of this purity, of this tidy feminine beauty that I resented: I didn't want to wear little dresses and sit still; I wanted to get into trouble, get dirty, discover, and invent.

I grew up on Vancouver Island, just outside of Victoria, British Columbia, a smallish town where my mom owned the local hair salon, and I was pushed to become a hairdresser. I was discouraged from art school, college, or university, so I took the path of becoming a hairdresser. But it was not a job suited for me in any way. I was a tomboy who couldn't seem to learn the ways of preening and fussing over my appearance. Eventually, I became a barber, which was somewhat better. Art was something I always did; it was how I made sense of the world, a way to bring the world in my head together with the world I lived in.

I went from hairdresser to barber to draftsperson to veterinary nurse to welder. I took art classes through all this but didn't actually get the courage to start my undergraduate degree until I was almost 30. My decision to go to trade school and become a welder in my 20s came from looking both for an occupation that was a good practical trade and a means to be able to build, to create works for myself. Working as a female welder opened my eyes to a new social world. The body and verbal language of the men in the metal shop seemed like overt attempts to fit into this invented macho world, which felt just as ridiculous as being in the world of a hairdresser.

Above: Cal Lane with co-curators Carla Bednar and Nancy Packer discussing the location for Lane's installation, 2008.

Page 79: Detail of oil tank created by Cal Lane for *Lace in Translation*, 2009.

Page 80: Artist Cal Lane. Courtesy of Cal Lane.

Page 81: Lace sample used by Cal Lane for inspiration (see page 15).

There are aspects of these gender extremes that felt oppressive and angered me, but I also found these same contrasts and conflicts somewhat amusing. If smoking a cigar and cursing made me a better welder, then so be it. One can put on many hats in life, and I have found dressing up a strange and interesting venture.

When I left my job at the welding shop to go to art school, I took these past experiences with me. While I was getting my sculpture degree at Nova Scotia College of Art and Design (NSCAD), I worked as the metal shop technician, then later taught a welding course for architects. I have worked in many materials, but kept coming back to steel. Steel is not just a material for me; it has become a metaphor for this extreme macho world, the cold, tough, strong, dirty, industrial world. I like to use discarded metal objects, objects that had a life and come with a story, objects that are symbols of our lives, hard work, and struggles. But I also love the poetry of how these huge tough objects dissolve, rust, corrode, and are reclaimed in nature by a gentle rain.

I also was attracted to the recycling aspects of working with this material. There seemed to be a lot of discarded steel car parts and home appliances littering the forests — objects that once had a use. I loved the idea of cleaning the forest, of finding a new use for an undesirable object. Each of these steel objects carried a different story, and though I adorned them with painstaking cut-work, they were still dirty, old, rusty, and discarded. I was looking to make a provocative object, not an ornament.

My experience as a female welder, funny enough, is what brought me to working with lace. Socially it was very interesting for a while, but it became a little tiresome, knowing that everyone was looking at you and waiting for you to screw up, wanting to verify their preconceptions. Lace became a metaphor for the adorned object, the woman that I refused to be. I was cleaning up the metal shop at NSCAD one day, and as a joke, I put real lace doilies on top of the equipment after I cleaned them, on the band saw, the anvil, the drill press. Visually I liked the contrast of materials — the white clean delicate lace draped over this dirty cold steel machine. But whether it was there to protect it or I was just marking my territory, I don't know. This brought me to create Industrial Doilies. I cut three-quarter-inch-thick steel with an oxy-acetylene torch into large, heavy, rough, hand-cut steel doilies. The lace patterns came out of my head. The Industrial Doilies were to me a symbol of contrast and balance, placing together visual oppositions: the male, female, the tough, delicate. But again, lace wasn't something I was attracted to. I would turn my nose up, calling it "girl stuff," like I didn't belong to it.

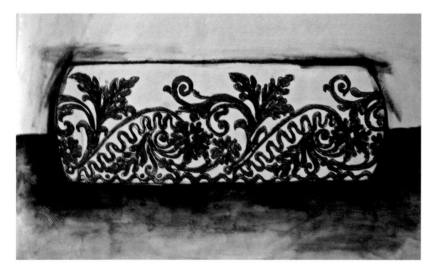

Rendering by Cal Lane of oil tank for *Lace in Translation*, 2008. Courtesy of Cal Lane.

After this I began to investigate lace itself and perhaps take a look at my own sexist behavior. I started using this lace tablecloth that my parents got as a wedding gift. I transferred the pattern onto a wheelbarrow and then hand-cut it using a plasma cutter. With this piece the notion of labor is celebrated. I visited the lace museum in Belgium and saw how handmade lace is made. I was attracted to the focus and repetitive motion of the work, much like welding and cutting. I began to learn the patterns and techniques of lace-making through welding.

I like to work as a visual devil's advocate, using contradiction as a vehicle for finding my way to an empathetic image, an image of opposition that creates a balance — as well as a clash — by comparing and contrasting ideas and materials. This manifested in the Industrial Doilies series — a pulling together of industrial and domestic life as well as relationships of strong and delicate, masculine and feminine, practicality and frivolity, ornament and function. There is also a secondary relationship being explored here, of lace used in religious ceremonies as in weddings, christenings, and funerals.

The old tattered bits of lace carefully arranged into books created a detailed study of patterns, like reading a visual novel of texture, color, and pattern.

The metaphor of lace further intrigued me by its associations of hiding and exposing at the same time, like a veil to cover, or lingerie to reveal. It also introduces a kind of humor through the form of unexpected relationships, like a wrestler in a tutu. The absurdity of having opposing extremist stances is there for reaction, not rational understanding; the rational discussion arises in the search for how one thing defines the other by its proximity.

My new work became more political as a consequence of living in a time of war and feeling the guilt of a bystander. In Filigree Car Bombing (2004), I focused on creating a tasteless relationship: images of flowers and "prettiness" in the form of a violent and sensitive situation. The crushed steel of the car is cut into fine lace, creating a drapery of disruption and sadness, a conflict of attraction to fancy work and attraction to a horrific image. Crude (2007) juxtaposed the relationship of God and Oil. Though dealing with overt political topics, the images do not point to anything specific — they merely coexist — and what they say really depends on the viewer. It includes a series of oil cans flayed open in the form of a cross or a Gothic cathedral floor plan, then cut into Christian or medieval-style icons. Fine, like tattered paper, the jagged edge of the thin metal becomes both an ancient and a contemporary image, appealing to both those who cling to history, and those who ignore it.

For *Lace in Translation*, I searched for an object that had a kind of presence and mass, that would never in a million years make you think of lace: something large, dirty, and demanding. Re-using a container that was meant to hold oil — which we associate with the political debates that surround CO_2 emissions, war, and modern lifestyles — and eliminating its functionality by piercing it and making it decorative turned the tank into something more frivolous, a forgotten fossil. Then the challenge was how to make it carry the design, feeling, and structure of the Quaker Lace sample I discovered in the vaults of The Design Center. Searching through the collection of lace pieces and garments was beautifully mysterious. The old tattered bits of lace carefully arranged into books created a detailed study of patterns, like reading a visual novel of texture, color, and pattern.

The lace pattern that I chose needed to have particular thicknesses and a certain kind of shape to maintain the structural integrity of the pipe-like steel tank. To consider the lace as a piece of structural engineering, as a structural steel object — it was interesting to think of lace in this way.

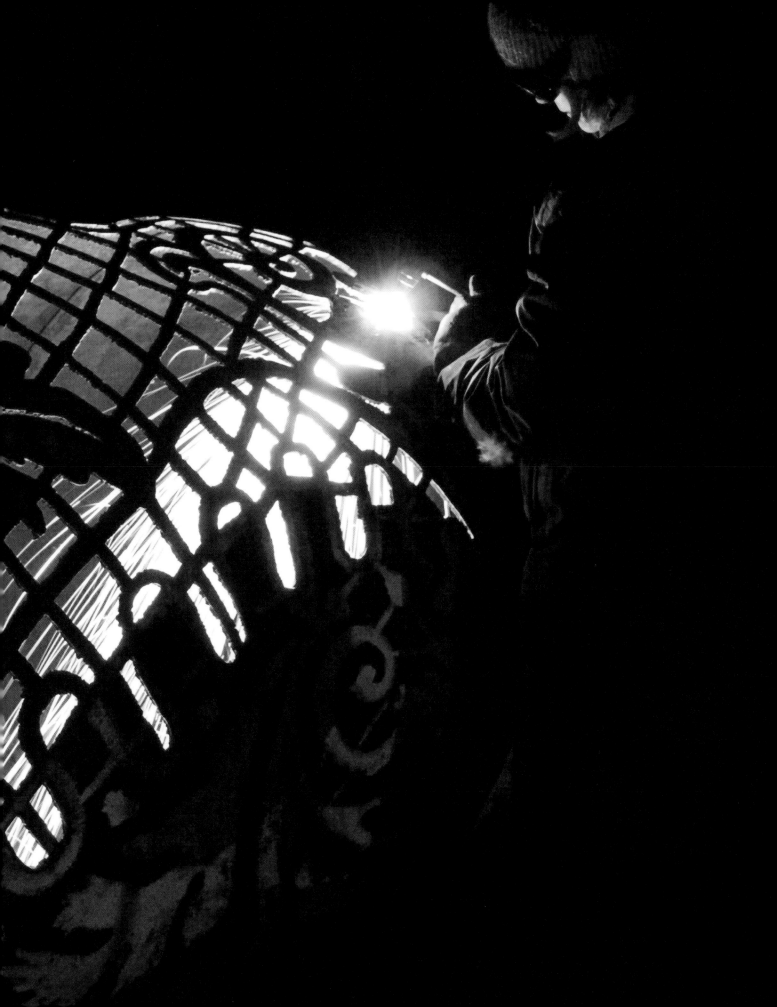

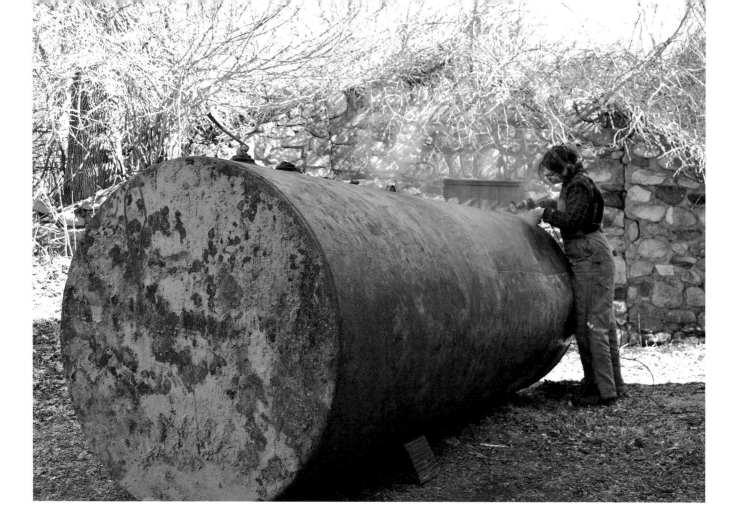

This page and facing page: Process images of Cal Lane creating oil tank for *Lace in Translation* including prepping the tank, painting the projected image of the Quaker Lace sample onto the tank, and first cuts, 2009. Courtesy of Cal Lane.

Page 85: The Quaker Lace motif emerges during night welding of *Lace in Translation*'s oil tank. Courtesy of Cal Lane.

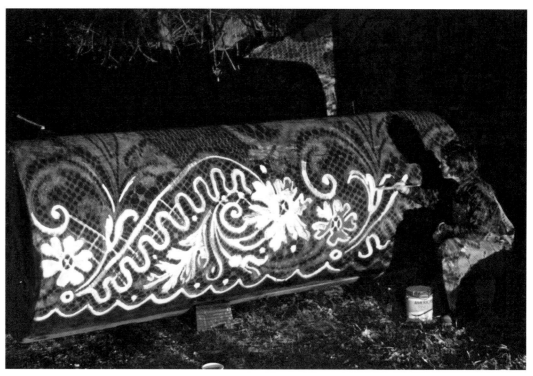

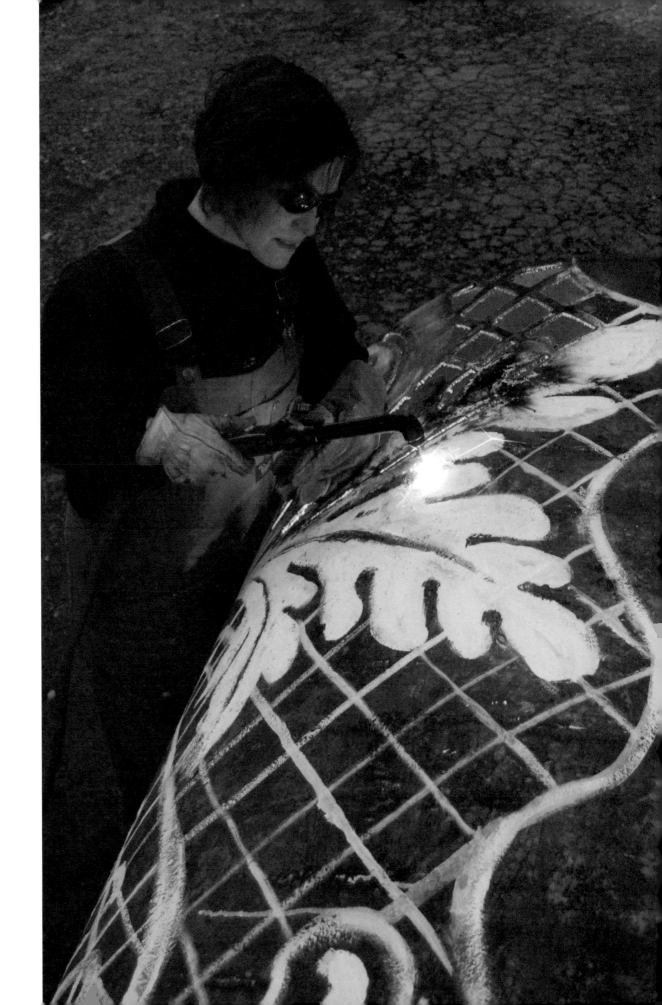

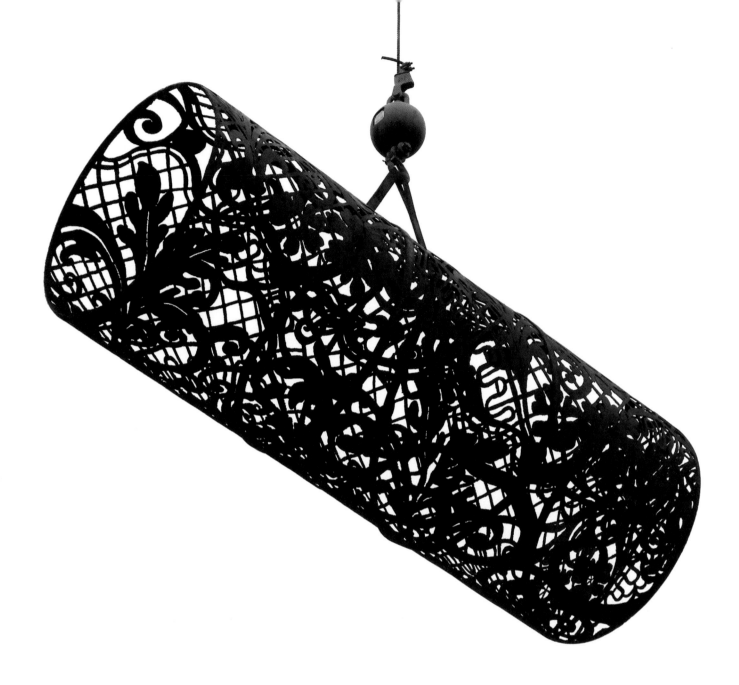

I WAS LOOKING TO MAKE A PROVOCATIVE
OBJECT, NOT AN ORNAMENT.

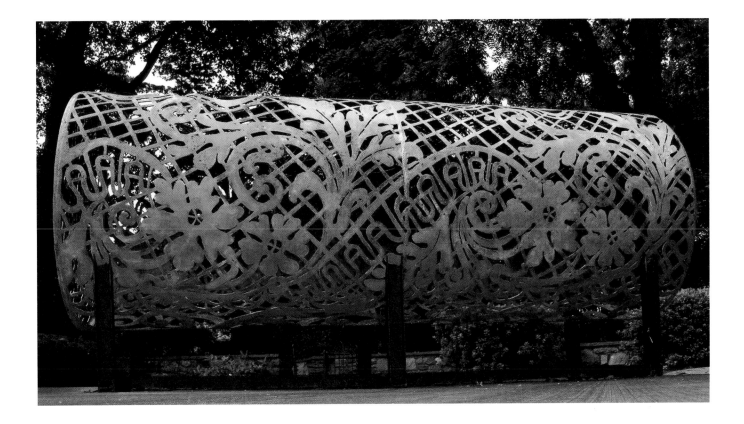

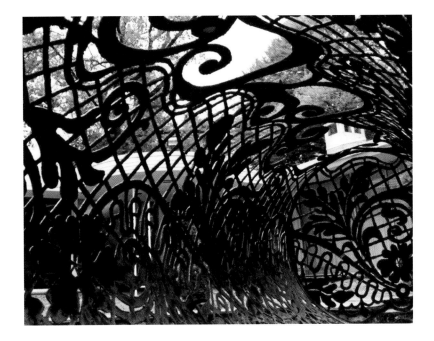

Above: Oil tank by Cal Lane as installed at The Design Center, 2009.

Left: View of tank from the inside looking out.

Facing page: Hoisted by a crane over The Design Center, the 600-pound tank is lowered into its proper station.

Pages 90 & 91: Autumn view of oil tank as installed in The Design Center's back yard.

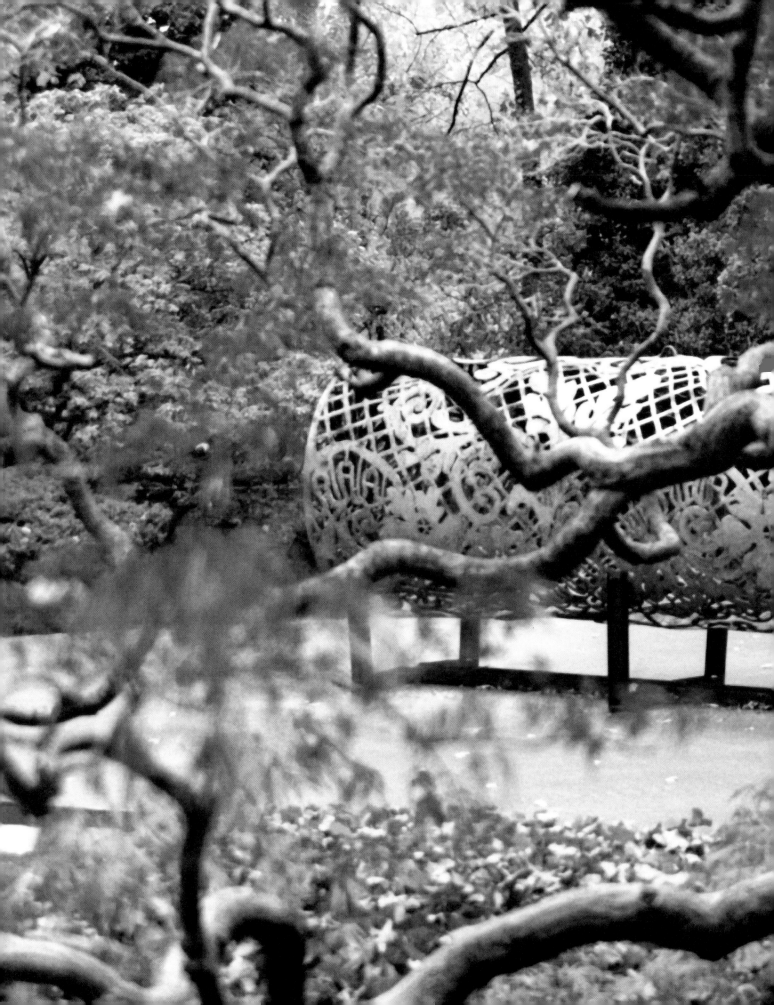

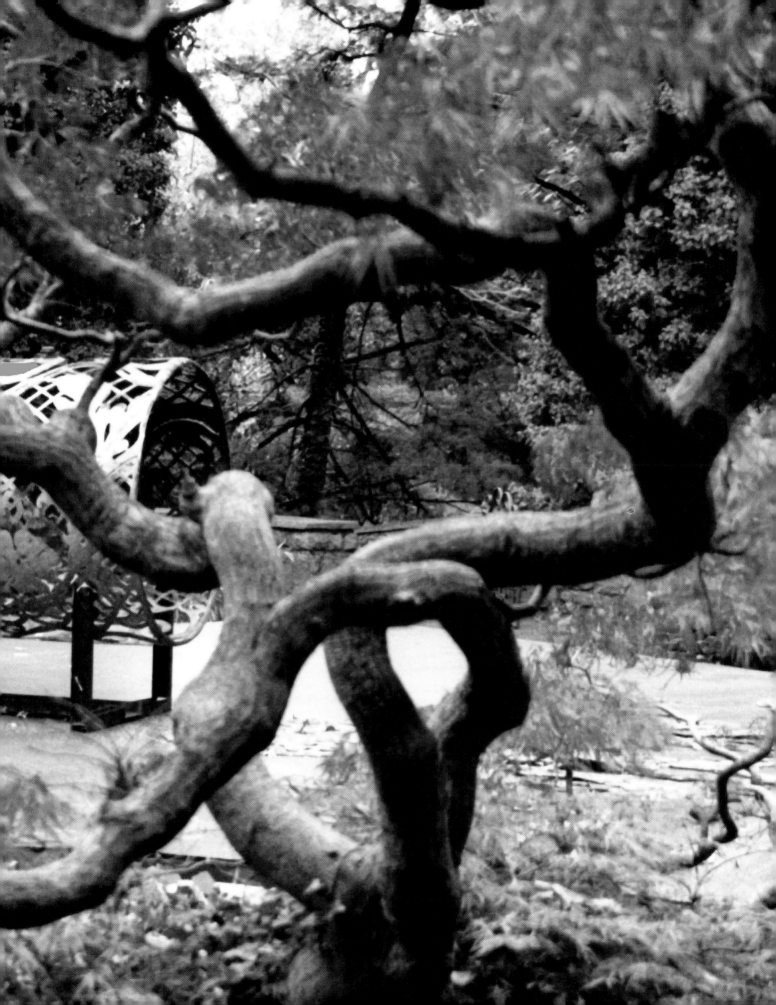

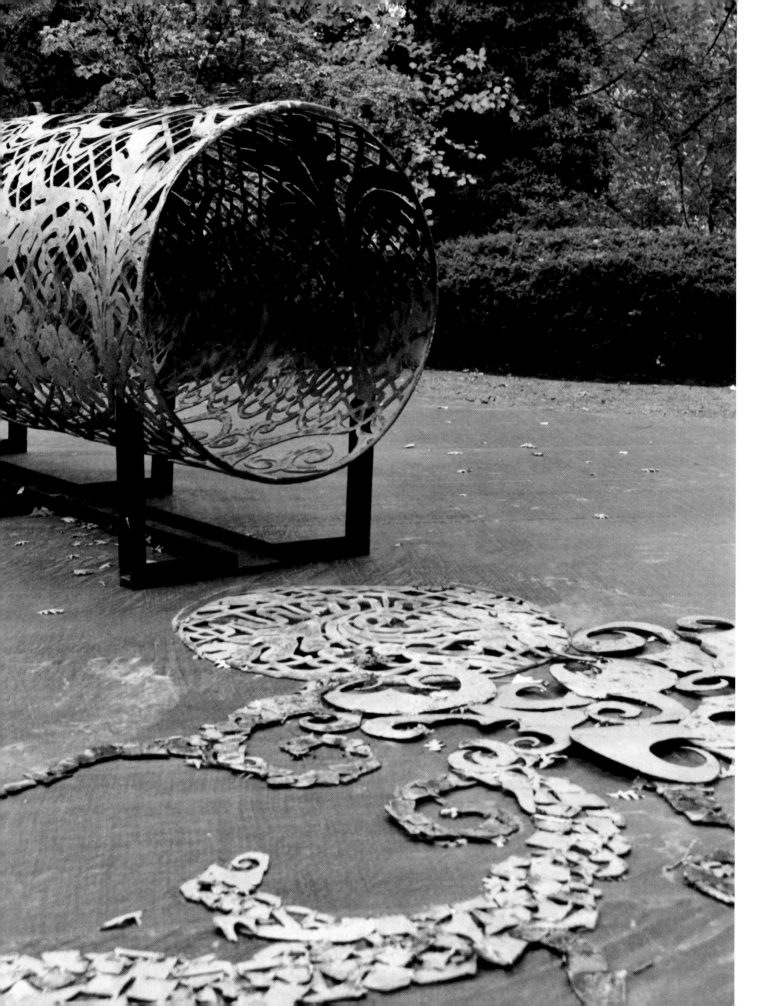

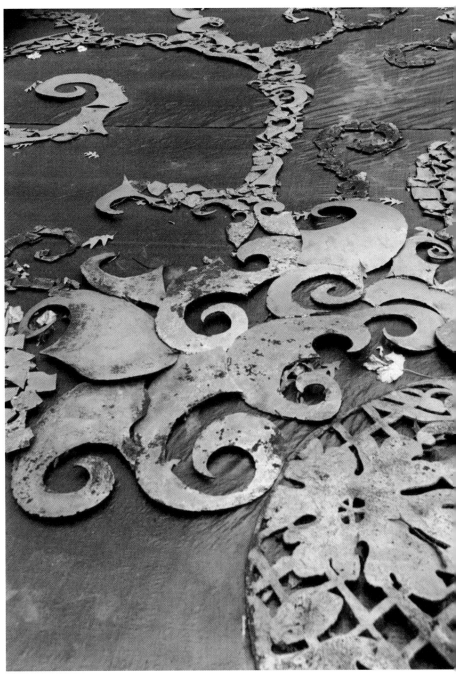

Above left: Interior view of the tank.

Above right: A fabricated oil spill welded from cut-out bits and pieces of the tank.

Facing page: Detail of the tank as installed, with detached end and "contents" spilling forth.

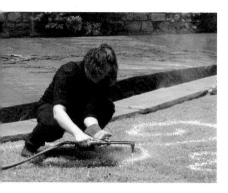

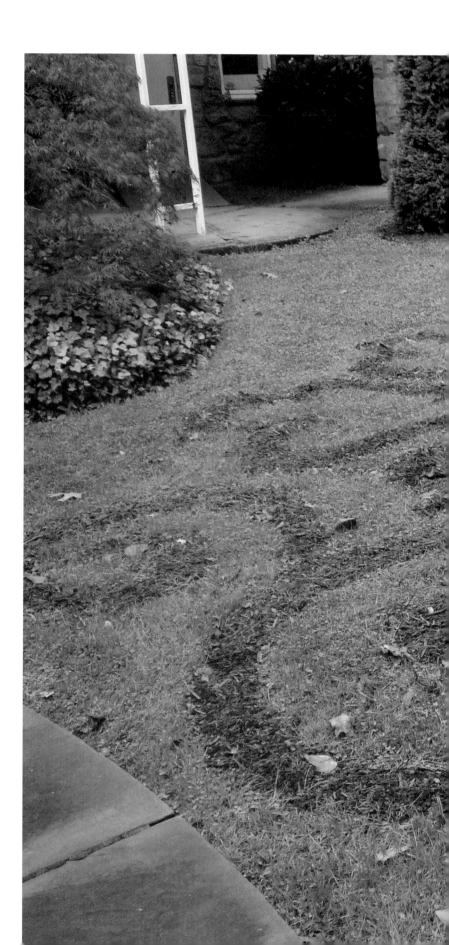

Above and right: Cal Lane's installation for *Lace in Translation* also features a torched lawn rendering of the Quaker Lace motif.

Pages 96 & 97: Detail view of the tank's patinated surface.

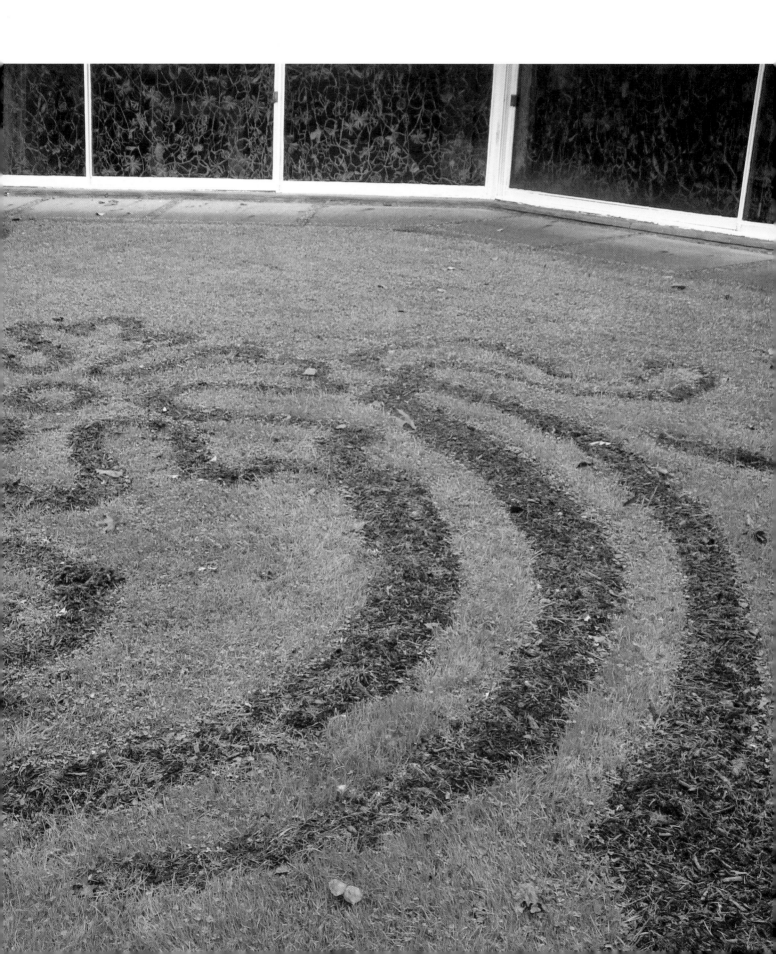

BIOGRAPHIES

Demakersvan (translated "the makers of") is a Rotterdam-based, Dutch design studio founded in 2005 by Jeroen Verhoeven, Joep Verhoeven, and Judith de Graauw, all born in 1976 and all graduates of the Design Academy, Eindhoven. Not limited to one category or style, this firm's diverse portfolio includes architecture, furniture, and product design for museums, architectural studios, furniture manufacturers, and fashion companies, as well as self-generated projects. Demakersvan describes itself as a story-telling design studio, referencing history in all of its productions.

One of Demakersvan's best-known products is Cinderella, an 'impossible' table produced by means of a high-tech CNC 5-axes cutting machine out of 57 layers of birch plywood. Both New York's Museum of Modern Art and London's Victoria and Albert Museum acquired Cinderella for their permanent collections. Works by Demakersvan have been exhibited at the Cooper-Hewitt National Design Museum; MoMA New York; Victoria & Albert Museum, London; Art Institute of Chicago, and other international venues. Their client list includes DROOG Design; FATBOY; Candy & Candy, London; Hauser & Wirth, Switzerland; Kakitsubata, Tokyo; HugoBoss; ORANGE SHOP; SeARCH Architects; Swarovski; and the Musea Brugge, Belgium.

Tord Boontje's iconic designs and products have propelled him into one of the most sought after industrial designers working today. Boontje was born in The Netherlands in 1968. He received two industrial design degrees: a B.A. in 1991 from the Design Academy, Eindhoven, followed by an M.A. in 1994 from the Royal College of Art, London, where he was recently named Professor and Head of Design Products. Since 1996, Studio Tord Boontje has created award-winning designs for Target, Swarovski, Moroso, Artecnica, Alexander McQueen, Habitat, Kvadrat, Swatch, and Perrier Jouët, among others and his work is represented in the permanent collections of the Victoria & Albert Museum, London; British Council, London; Crafts Council Collection, London; Cooper-Hewitt National Design Museum, New York; Indianapolis Museum of Art; MoMA New York; MoMA San Francisco; and the Philadelphia Museum of Art.

Tord Boontje and Studio Tord Boontje have received numerous awards, including a Red Dot Design Award; IF Product Design Award; 2005 Dutch Designer of the Year; Cologne Fair Innovation Prize for textiles; Elle Decoration International Designs Best Lighting Design; Dedalus Design Award; 2004 New York Gift Fair Best Product; Designer of the Year 2003, Elle Decoration; Short-listed, Designer of the Year 2003, Design Museum London; and the Bombay Sapphire Prize for Glass Design. Boontje is the subject of *Tord Boontje*, a 2007 biography by Martina Margetts published by Rizzoli, New York.

Cal Lane is an internationally acclaimed sculptor having won prestigious awards, media accolades, and extensive curatorial attention over the past decade. She has been the subject of articles in *The New York Times*, *Artforum International*, *American Craft Magazine*, *The Village Voice*, and *The New Yorker*, among others. Lane's work has been mounted in exhibitions at the Musée des Manufactures de Dentelles, France; the Musea Brugge, Belgium; and New York's Museum of Art and Design, and in art galleries from California and British Columbia to New York and Nova Scotia. She is currently working on a major project in Tivat, Montenegro. Lane was born in Halifax, Nova Scotia, Canada in 1968. In 1994, she received a Diploma in Fine Arts from Victoria College of Art followed by a certificate in welding from Camosun College, both in Victoria, British Columbia. In 2001, Lane completed her B.F.A. at Nova Scotia College of Art and Design and received an M.F.A. in sculpture in 2005 from the State University of New York, Purchase, where she taught courses in sculpture, materials, and contemporary practices and theory. She was recently awarded the Joseph S. Stauffer Prize from the Canadian Council for the Arts.

Guest essayist, **Matilda McQuaid** is deputy curatorial director and head of the Textiles Department at the Smithsonian Institution's Cooper-Hewitt National Design Museum, where she organizes exhibitions and publications and oversees one of the world's premier textile collections. Previously a curator at the Museum of Modern Art, McQuaid has authored a range of books and articles on art, architecture, and design including *Envisioning Architecture: Drawings from the Museum of Modern Art* (2002) and *Extreme Textiles: Designing for High Performance* (2005).

From left: Hilary Jay, Nancy Packer, Carla Bednar.

End page: Detail of late 19th-century American machine-made lace (see page 19).

Inside back cover: Detail of pencil sketch by Frederick Vessey, 1893. Collection of The Design Center at Philadelphia University, gift of Ruth and Eric Vessey.

Back cover: Detail of sketch by Frederick Vessey, pencil on paper, ca. 1890–1910. Collection of The Design Center at Philadelphia University, gift of Ruth and Eric Vessey.

Award-winning journalist, curator, and entrepreneur **Hilary Jay** is executive director of DesignPhiladelphia, an annual city-wide festival of design exhibitions, lectures, symposia, book signings, and special events. From 2000 to 2009 she was director of The Design Center at Philadelphia University where she created exhibitions and programs championing multiple design disciplines. In the 1980s, Jay co-founded Maximal Art, an international costume jewelry and watch company. Jay's jewelry is in the permanent collections of the Victoria & Albert Museum, London, and the Musée des Arts Decoratifs, Paris.

Curator, artist, and educator **Carla Bednar** has spent more than 25 years bringing art and design to the public. Currently assistant director of The Design Center at Philadelphia University, she co-founded The Fabric of Philadelphia, a heritage initiative exploring the role of textiles in shaping Philadelphia, past and present. In the 1990s Bednar founded and directed *Make and Take a Masterpiece* and *Out and About Art*, award-winning programs that introduced students and their families to internationally acclaimed art, architecture, and design by exploring collections and artifacts in local, regional, and national museums.

Collections curator of the textile collection at The Design Center at Philadelphia University from 1999 to 2010, decorative arts and cultural historian **Nancy Packer** seeks to illuminate the social and cultural issues embedded in historic artifacts through research, programming, and exhibitions. A doctoral candidate in history at the University of Delaware, Packer is co-founder of The Fabric of Philadelphia. She previously served as Curator of Collections for the Association for the Preservation of Virginia Antiquities, and Education Director of the Bayou Bend Collection at the Museum of Fine Arts, Houston, and is currently Chief Curator of Tryon Palace Historic Sites and Gardens in North Carolina.

ACKNOWLEDGMENTS

The Design Center at Philadelphia University and the exhibition curators would like extend their personal gratitude to Tord Boontje; Cal Lane; Joep Verhoeven and Demakersvan; Paula Marincola, The Pew Center for Arts & Heritage and Philadelphia Exhibitions Initiative; Ward Mintz, The Coby Foundation Ltd.; Matilda McQuaid, Cooper-Hewitt National Design Museum; Daniel Fuller, Philadelphia Exhibitions Initiative; Roy Wilbur, Marketing Innovation Program; Joseph Newland, Q.E.D.; Lynn Catanese and Jon Williams, Hagley Museum and Library; Nikki Nelson and Betty MacDonald, Liberty Lacers; Holly Van Sciver; Susan Drinan, Atwater Kent Museum; Jarrett Seng, Raceseng Design; Paul Swenbeck, Jacob Lunderby, and Tristan Lowe, Wormwood and Haze; Megan and Mason Wendell, Canary Promotion + Design; John Refano, Canary Promotion + Design; Artenica, U.S.A.; Kvadrat, Denmark; Marcia Weiss, School of Engineering and Textiles, Philadelphia University; Hy Zelkowitz, School of Design and Media, Philadelphia University; Jane Epstein, Rock it Cargo; Katrina Hallowell, Dietl International; Andrea Hemmann and Cara Cox, GHI Design; Kerry Polite, Polite Design; Beth Van Why, DesignPhiladelphia; Marty Birnbaum, Westchester Lace & Textiles, Inc.; Ben Suplick and the Physical Plant Department, Philadelphia University; Tim Butler and Warren Young, Campus Center/Student Activities, Philadelphia University; Grace Machaqueiro, Catering, Philadelphia University; Alana Rosenwald; Philadelphia University students Kira Bednar, Lara Coleman, Kendra MacLean, Angela Mills, Sarah Moore, Carin Sauerwein, Lei Ting, Kaitlyn Usher, and Liz Weissert.

Special thanks to the raffia lace curtain production team directed by Carla Bednar with assistance from Professor Marcia Weiss, School of Engineering and Textiles, Philadelphia University: Meg Adams, Wendy Anderson, Lisa Ault, Ryan Bednar, Patricia Brennan, Candy Depew, Lynn Golden, Amy Hankin, Ramona Huynh, Alan Jalon, Hilary Jay, Rebecca Kanach, Richard Kelly, Robin Kralik, Warren Lewis, Kendra MacLean, Lauren McEwen, Sarah Moore, Nancy Packer, Lauren Pifer, Joyce Reber, Alana Rosenwald, Carin Sauerwein, Jennifer Sulikowski, Lei Ting, and Kaitlyn Usher.

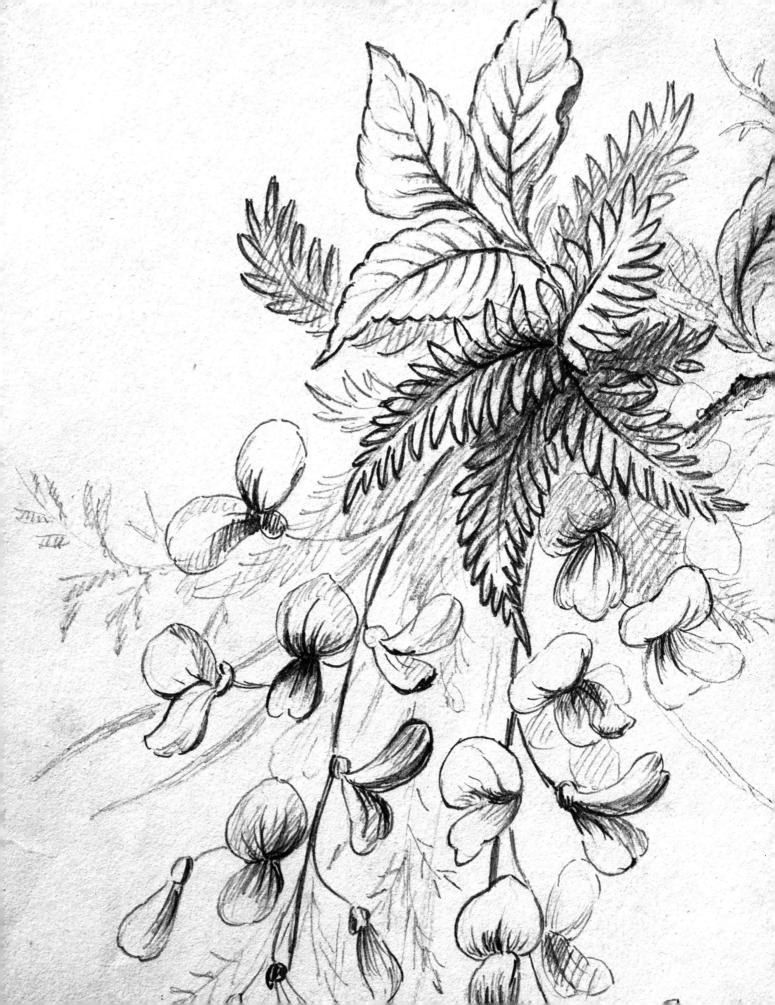